CREATIVE STRENGTH T NG

Promp al Stories
for enius

NORTH LIGHT BOOKS
CINCINNATI, OHIO

clothpaperscissors.com

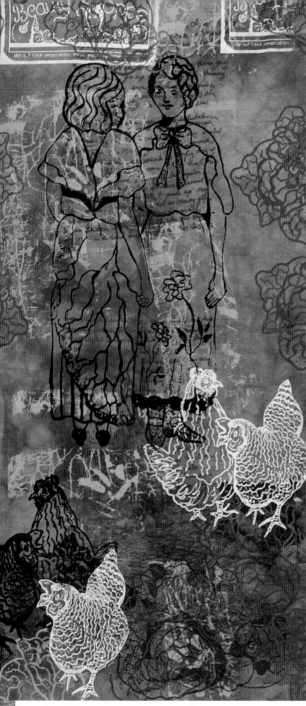

CONTENTS

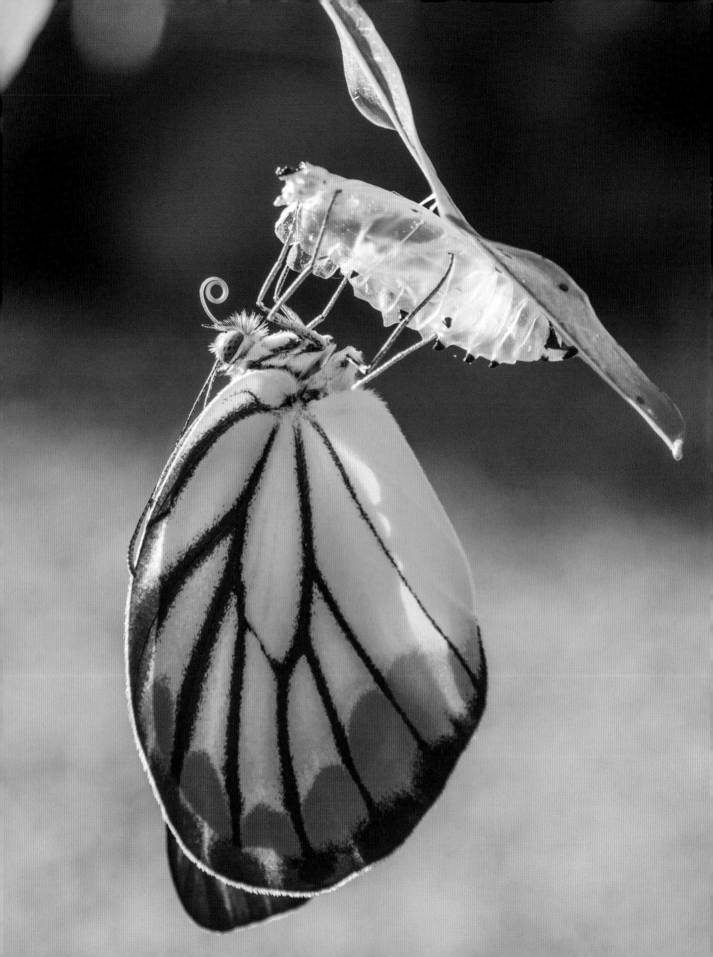

AN INTRODUCTION

A Transformation Period

I've worked with hundreds of students and authored a half-dozen books, and usually, if asked where to begin, I would say "Jump in!" And you can certainly jump into this book anywhere—on any page—and find something that will interest or intrigue you.

But there was a rhythm to how I originally conceived this material and how I think it will work best for you, the reader.

The strategy is . . . to begin at the beginning! The chapters here are laid out in a natural order that makes sense. One follows logically after the other.

Here's a visual: It's a little like reading about how a butterfly is first a caterpillar and then spins the cocoon. Then the waiting time—a transformation period—ensues. You can read about it, but if you are watching a real caterpillar spin a real cocoon, you can't change the order of events and you can't speed up the process. It takes the time and order that it takes.

And that's true with *Creative Strength Training*, too. You can read a little here and there to get an idea of what it's all about, but when you're ready to get started, it helps to begin at the beginning, trust the natural order of things and then just do the work. Your transformation is waiting in the wings. Welcome. Let's get started!

One more note about how the book is set up. In addition to my essays, you'll encounter cross-training exercises that feature writing and hands-on activities. I've also included an "Artists Respond" component to the book. These real-life stories of how other artists have explored Creative Strength Training—and how it benefitted them—are poignant, funny and a gift to you, the readers. I hope you'll find them as touching and inspiring as I did when I first read them as part of the online training program that inspired this book.

So welcome! Let's get started!

We delight in the beauty of the butterfly, but rarely admit the changes it has gone through to achieve that beauty.

◈ Maya Angelou

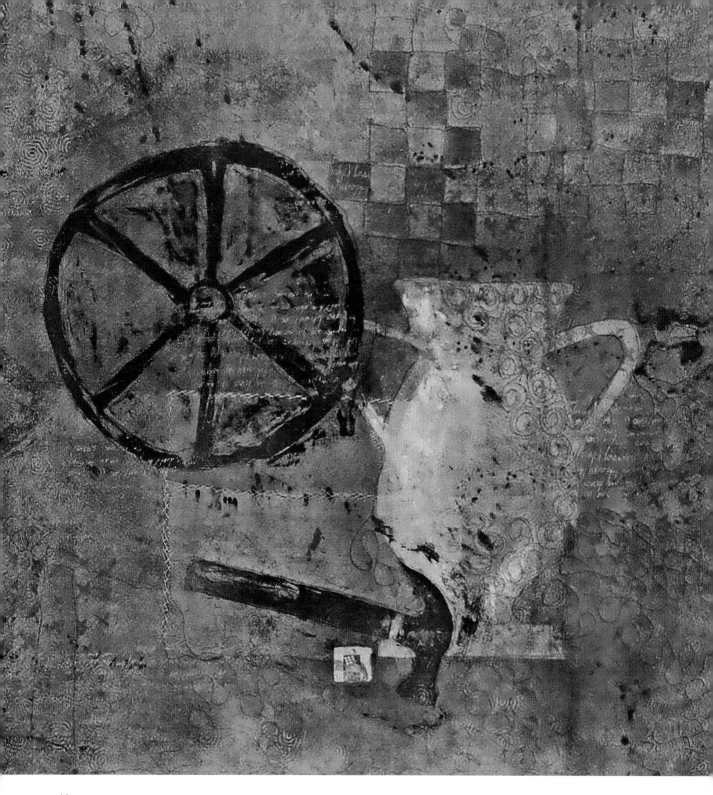

Verse 11
Jane Dunnewold, 2001
48"× 48" (122cm × 122cm)

CHAPTER 1

Defining Creative Stamina

STRENGTH TRAINING FOR ARTISTS

Maybe it's disingenuous to think each of us has the potential to be a creative genius. Talent is dispensed unequally at birth. Humans are tangled balls of social conditioning, environment and serendipity. Life isn't fair. Luck plays a part. We've all heard someone say, "I was just in the right place at the right time" or "I never get lucky."

A strand of this fatalistic thinking weaves in and around the subject of creativity. Most people believe you've either got it or you don't. I can't tell you how many times I've heard someone say rather wistfully, "I'm not creative." When I hear a statement like that, I think to myself, *No one has ever shown you where to begin.*

Because the fact is, creativity, like any skill, can be cultivated. It takes a healthy combination of focused commitment and strength training, knowledge and stamina.

Think about it. Tour de France bicyclists don't know how to ride at birth. First they learn to walk and then they learn to pedal. Winning the Tour de France isn't spontaneous. It starts with learning to ride a bicycle. It culminates in a win preceded by years of strength training so the winner's body and mind work in tandem to master the race.

We join spokes together in a wheel,
but it is the center hole
that makes the wagon move.

We shape clay into a pot,
but it is the emptiness inside
that holds whatever we want.

We hammer wood for a house,
but it is the inner space
that makes it livable.

We work with being,
but non-being is what we use.

◈ Tao Te Ching
translation by Stephen Mitchell

Athletes have the advantage of prescribed methods of building stamina because physical prowess is revered by our culture. Hire a personal trainer and you'll do repetitive exercises, gradually adding reps as your body gains strength. Stay on one track and parts of your body get stronger, but other parts languish. What will the personal trainer do? Introduce cross-training. One session running, to ramp up your cardio. Next time? Yoga to maximize flexibility. A steady, balanced program of activity is required to keep the human machine functioning at optimal level.

An additional benefit? Runner's high—an elevated mental state athletes report when their bodies are pushed to the brink of endurance. More than one athlete has described the experience as akin to a meditation practice. Many agree it's this meditative state that keeps them running, biking or working out as much as exercise itself. Transformed strength, flexibility and stamina are great, but there are unexpected side benefits: greater self-confidence and heightened self-worth. In the process of training the body, the elation of discipline is discovered. It's a win-win.

Musicians embrace a similar practice. Études are musical studies employed to master an instrument. Talking with musician friends, I realized études are also a form of meditation. The potential exists for the playing to center the player. This explains why a player with a thirty-year career would continue to play études. The daily practice is its own reward.

Études are an example of how individual meditation practices unfold. Some people sit zazen and om every day. Others join a prayer circle. Musicians practice instruments. As an artist, I achieve daily centering in the studio. I didn't know how to find my center at the beginning. I flailed but gradually settled into a practice. I began to understand how to sustain creative ability by regularly creating. That's why they call it a practice. Go to the studio and make something. Go to the studio and make something. It's just another version of reps.

When I realized behaving creatively could be translated into a series of steps, it rocked my world. Step-by-step learning demystifies physical exercise or playing an instrument. Why shouldn't it demystify what happens when we are deep into making?

A disclaimer: Sure, people use what they learn to varying degrees of success. It would be disingenuous to act as though some people won't be better at this than others. Lots of variables affect how much someone achieves as an artist/maker. But if the strategies of strength training are applied in the studio—that is, by setting a course of learning and gradually increasing reps—creativity expands, and so does an artist's sense of confidence and self-worth.

This is only one of numerous paradoxes encountered in Creative Strength Training. Making begins as play, then gets serious because you start to care. You recognize the need for regular reps or practice and screw up your courage to commit. What happens? You come full circle. Stick with the training. Working at it leads back to play.

T.S. Eliot said it best in *Four Quartets*, when he wrote:

> *We shall not cease from exploration,*
> *and the end of all our exploring*
> *will be to arrive where we started*
> *and know the place for the first time.*

CHECK IT OUT

If you experience a strong hit of pleasure from working, you want to keep going. When you're stuck, you don't panic. You know you'll get past it. You tap into the same high described by runners. Have you ever been in the studio, looked up at the clock and thought, *How could four hours have passed?* That's what we're talking about. Being so immersed in process, time stands still or speeds by, depending on your perspective.

Be at least as interested
in what goes on inside you
as what happens outside.
If you get the inside right,
the outside will fall into place.

◈ Eckhart Tolle

Some people sit in meditation.
Others practice an instrument
or write poetry.

WRITING AS AN ASSIST TO MAKING

I don't know why artists resist the idea of a regular writing practice, which, by the way, is different from thinking of yourself as a writer.

Journaling's reputation has morphed from angst-filled recordings of adolescence and true confessions into a legitimate art form, which is all well and good but not what I have in mind for this writing practice.

Writing exercises are cross-training. Each assists in the management of studio time and in the creating itself. Practically speaking, few of us keep all the great ideas we have in our heads. Writing down ideas tethers them to the Earth plane. List making is good. Make a list of pieces you'd like to attempt eventually. Make a list of pieces that could spring from one topic.

For what it's worth, I make notes at every stage of a work's development, not for posterity's sake (I can only hope) but because when I go to the studio tomorrow, I will remember what I intended to do. Just because I am intentionally mindful doesn't mean I have a great memory. In fact, writing down what I want to do next frees me to think about all the other ideas floating around inside my brain.

List making serves a purpose: It stays the course. That's not hard to acknowledge. But what about a case where you're stuck? All good ideas have left the room. Maybe you are new at this. You don't know where to get ideas yet. Maybe you are transitioning. You always used someone else's tools and designs: rubber stamps, paint-by-number kits, stencils, assignments, etc., but now you want your own sensibility to lead. Or maybe you've been at it awhile. Do you have a ton of techniques but can't generate your own ideas when it comes to using them? Help! Help!

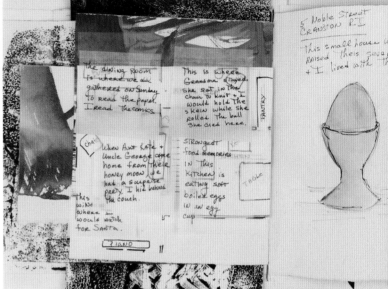

Joanne Weis used her journal to explore writing and preliminary ideas for artwork.

CHECK IT OUT

Here are a few guidelines to help get you started:

◈ No one will see what you write unless you choose to share it. If you are concerned that someone around you would read your notes uninvited, write on the computer and require a password to get into the file, or use a tried-and-true protection: Hide the notebook under the mattress. But don't stop writing.

◈ Avoid writing as though you are on stage, in other words, seeing yourself in the third person, where you become the audience. It doesn't really work out. You aren't connected to your words.

◈ Use whatever writing methods suit you. If incomplete sentences are your style, go for it. List maker? Fine. Stream of consciousness and long-winded? Put it on paper and it's all good. Writer Anne Lamott calls this style of writing the "shitty first draft." You can always edit later.

◈ You may be surprised at how easy and interesting this is. Or it may not feel that way at all. Remember the commitment you've made to your Artist Self. Whether it feels great or not, keep writing. Remember, this is cross-training and it will be productive over time.

And sad but true, you could also be someone who's been sailing right along on a glossy sea of great ideas, but one morning you wake up, the tide's gone out and every worthy idea has gone with it. You're stranded.

That's where a different kind of writing is valuable, because for once in your life, it really can be all about you, which is fabulous. Stories, thoughts and events—layer upon layer of experience. You contain all the inspiration you need to tell great stories through your art. Maybe you need a little practice learning how to access it and make it visual, but that's why you're here.

I know, you're still worrying that writing exercises aren't related to making art. A more straightforward approach would be about color, design or motif ideas. But plenty of approaches already deal with design, color and process. In order to sharpen personal creative acumen you must get in touch with yourself. What are your ideas, feelings and thoughts about life? When you pay close attention to your own ideas and experiences, your creative energy distills. Who knows more about what you care for or what has happened in your life than you? And what more authentic source exists as inspiration for making art?

Don't worry that the past wasn't pleasant or perfect. You aren't alone. There is absolutely no obligation to start with hard stuff. What you think about and write is your choice.

Eventually you may realize taking a good look at unfortunate things that happened to you actually begins to dismiss their power over your thoughts, but that's not right now and not this writing assignment. So take a breath and relax.

WORKING WITH MEMORY

CROSS-TRAINING EXERCISE

PART 1

Choose one of the following topics and write about it. Don't worry if the writing isn't in sentences. *No one will see the writing you do but you* unless you choose to share it. Jot a list if it's easier; sketch if it seems appropriate; use a format that works for you.

OPTION 1

Write about the first cloth in your memory.
- » How old were you?
- » Where did it come from or where was it?
- » Who did it belong to?
- » Who made it?
- » Why do you remember it?
- » Why was it significant?
- » Add anything else you may think of while writing.

OPTION 2

Write about a garment you remember from your childhood.
- » Your earliest memory of a piece of clothing.
- » A favorite piece of clothing.

Writing about childhood memories is a good way to shake up your mental and emotional equilibrium; loosening images and ideas can transform them into content for artwork.

A willingness to remember the past through writing is a rich resource. Comics look at the foibles of their childhood, put an ironic or humorous spin on past events and make us laugh.

You, the Artist, can write about memories from past events with imagery in mind. Keep a running list of images that pop into your head as you write about your life. You won't know how to use images immediately, but eventually what you write could evolve into subjects for a work or series of works or design elements.

WHAT TO GATHER

- ◈ favorite writing implement
- ◈ something to write on (journal or loose paper)
- ◈ mixed-media materials of your choice (optional)

Don't limit your list to objects. A running list of smells, sounds and tastes is also a rich resource.

This strategy makes you a hunter-gatherer of past ideas, images, sights, sounds and tastes. The richer your sensual and psychological wellspring, the deeper your work can go.

PART 2

Drawing and sketching places you have lived, places you have visited and places you love are good ways to tap forgotten ideas and images. Allowing the subconscious mind to guide you while you draw, sketch, paint or stitch encourages information to float to the conscious surface. Paying attention allows you to capture mental meanderings for future use as figurative and symbolic reference material.

Draw a picture of a favorite room where you grew up. If you grew up in more than one place, pick a room with fond memories and happy associations. Show everything you can remember, either in a drawing or floor plan. After drawing, write about that room, why it was so pleasant and anything else that comes to mind.

These are strength-training exercises that focus attention on detail and cultivate imagination.

When I was about 5 or 6 my Mother made a dress for me.

Home felt warm and comforting, safe and reassuring

I thought of it as my carrots and peas dress

I do not have a picture of myself in the dress, only my memory

Orange, my first knitted jumper, the walls in my room, paperbacks, vit C

Many of my clothes were home made, there was not a lot of money to go round

The sun is shining into the room where I am standing. It is warm, a summers day

The fabric was white with vegetables printed in green and orange

The dress was made from new fabric - not second hand

I see myself standing, enjoying the moment, wearing a pretty dress

Making clothes The enjoyment of looking for a pattern, being involved in the act of making

The taste of tender young carrots, growing in a row

I am in the garden with my Dad 'helping' to weed the vegetables

Green, my Dads jumper, the shed my brothers 'Meccano' set, a dress made from a pattern in a magazine

Paper patterns, the smell of folded tissue in the packet and new fabric

Peas, round and sweet, the snap of the pod. Summer Days

There are as many ways to do the writing as there are artists. Chris Rodrigues chose to do her writing inside blocks of painted watercolor.

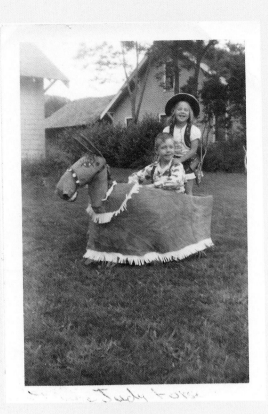

Judy Cook and her brother prepare for the Fourth of July

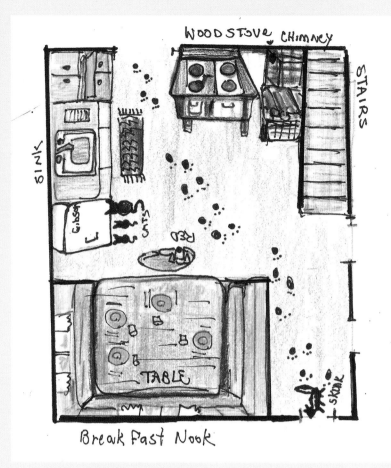

Judy's drawing of the floor plan of the kitchen in the house she lived in as a child

We lived in a little town with a big Independence Day celebration complete with a carnival, rodeo, parade and fireworks. It was my favorite holiday. One of my first memories is of riding my papier-mâché horse (a.k.a., decorated tricycle) in the Fourth of July parade. Decked out in my spiffy cowgirl outfit, I was Annie Oakley on my horse Target, prancing down the street waving at crowds of cheering admirers. Complete with a vest, fringed skirt, hat and trusty six-shooters in my holsters, I loved my cowgirl outfit. I think it was black. The only thing I didn't have was a pair of red cowgirl boots and I'm pining for them still.

❖ Judy Cook

I was born in front of the wood cookstove on the first day of fishing season. The chimney was old like the rest of the house. Whenever Mom got the stove hot enough to bake something, the chimney caught fire. Family legend is that I quickly departed the house and watched the fire from across the street on the pitcher's mound in the Little League park. My brother would be sent to fetch me when it was over. I had strong survival skills even then. We were all relieved when the woodstove was replaced by an electric range. I don't know how big that table really was, but in my memory it was huge. We spent a lot of time baking cakes, cookies and pies. I learned to cook and sew at that table.

❖ Judy Cook

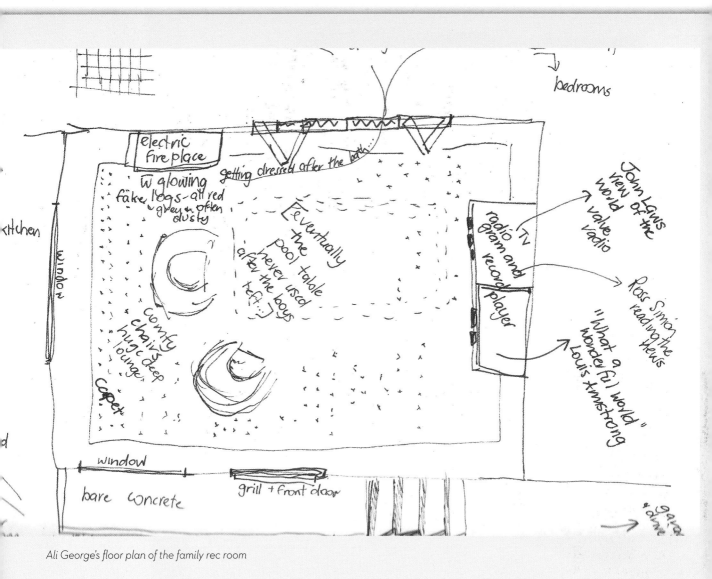

Ali George's floor plan of the family rec room

First cloth memory? A piece of fabric to complete a home economics project, a skirt. It was red-and-yellow patterned, tightly printed and somewhere between a heavy twill and corduroy. I made the skirt so short it was mistaken for a belt. Unwearable.

I'd never sewn anything before although Mum sewed many of our early clothes. I remember my sister and I feeling so special in matching pink hot pants (oh, were we naïve!) and not knowing we were laughed at and ridiculed for matching.

I never wore that skirt. Too short. Horrid. Funny, now I can stitch thousands of small pieces of cloth together but have never stitched clothing. I hadn't thought about the negative experiences of sewing before now. I was twelve or thirteen when I made that skirt and the legacy is powerful. Part of the overall unpleasantness of high school—not fitting in, an absence of social and other skills, sadness. It's a sadness I'm hugging and holding close and letting it play out, perhaps for the first time. It surprises me how much I am physically experiencing the memory.

❖ Ali George

Fashionista
Clairan Ferrono
Appropriated clothing, piecing
and quilting

I realize, remembering clothes, that I have always been most concerned about color and texture, even as a young child. I remember painting flowers in kindergarten: red, purple and blue—my favorite color combination. And now I'm remembering the romance of the painting smock!

After my mother died, and when I had begun art quilting, I made a couple of quilts out of clothes she, I and, my daughter had worn. *Fashionista* is an example.

❖ Clairan Ferrono

Gay Kemmis's Grandma
crazy rug

I grew up in the hopeful, prim days of brown-and-orange plaid upholstery, swanky kitchen appliance color names like Avocado and Harvest Gold (meant, I suppose, to convey a comforting "No one will starve in this house of plenty!" message). The linoleum looked like actual brick! What does this have to do with my first memory of cloth? Everything.

From the first baby blanket to the quilts and rugs of scrounged means, every single item my grandmother made possessed a dodgy alchemy that corralled the screaming disharmony of her color relationships and pattern clash-riots into something great, and like a bad boyfriend, impossible to quit. Every gift of hers seemed like a bit of naughtiness snuck into our house, and I was the one who got to let it loose.

When I was about seven years old, my grandmother made me a small hooked rug, using up old wool garments she'd cut into strips. I believe it was my Christmas gift that year and I was crazy over it and so was my mother but for very different reasons. I thought, *I have a magic carpet!* My mother thought *A very serious injustice has occurred because my child has been given an ugly rug made of old clothes!*

This "ugly rug" has been a constant companion through numerous moves, a steadfast riot of color in the parade of crappy and not-so-crappy apartments I've inhabited over the years, and an object that still makes me crazy happy every time I feel its thrifty nubbiness beneath my feet.

❖ Gay Kemmis

Deborah Franzini's special dress sent by her Swiss aunties

My first memory of cloth is clear and vivid in my mind and is linked with a first moment of conscious being.

I remember it with the kind of clarity reserved for moments out of ordinary time; you know, the things in our lives we remember with a clearness of detail as if they just happened?

I was quite young, following Mom dutifully into the house when I looked down at myself thinking *Wow, here I am! Where am I exactly? Why am I so small?* And as if a lightbulb had gone on, there I was in my little girl body in my dress sent from Swiss aunties.

All week I have searched for the photo of me in "the dress." I know it is buried here somewhere in the hundreds of memories saved on Kodak paper, stored in Ziplock bags and shoeboxes. I couldn't find the photo, but I knew exactly where the dress was: safely and lovingly stored away!

❖ Deborah Franzini

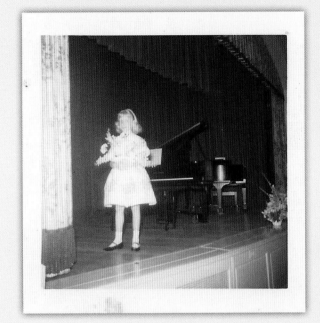
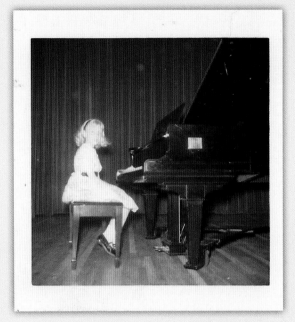

Louise Bateman's first piano recital

My mother made this dress for one of my piano recitals without using a Simplicity or McCall's commercial pattern. I was in awe and thought I wore the most beautiful dress at the recital! The pattern pieces were cut from brown paper grocery bags that had been opened so they could lie flat. I was so taken that you could purchase a yard or two of fabric and turn it into a beautiful dress.

❖ Louise Bateman

CONCLUSION

How would you use the memories that bubbled up through writing as inspiration for artwork? That's something to think about. And a topic we'll soon pursue.

Joan of Arc,
a rebel worth admiring!

Overcoming Stumbling Blocks,
PART I

GET YOUR REBEL ON:
THE POWER OF
BREAKING THE RULES

What keeps you from making? I'll admit to days when I spent most of the time thinking about going to the studio without ever going there once. Sure, there's a laundry list of other stuff that needs to be done. Some of it isn't negotiable if you have kids, aging parents or the plumbing is backed up and the bathroom is flooding. Priorities are priorities and there's no way around the urgency of a flat tire or the fact that you're going to be late for work if you don't get moving.

Bottom line: Life enters in. But in and around Life happening are portions of time just waiting to be dealt a creative hand. Don't you want to grab that time and go? Get busy? Make something?

In this chapter we consider common obstacles that squelch good intentions and flummox budding practices. And we engage a little rebel energy to break a few rules and think about charting a plan.

On an airplane they tell you to put on your own oxygen mask first before helping the person next to you. It's a good life strategy. Engage your rebel energy and protect the time that isn't co-opted by higher priorities. Even a brief stint in the studio has the potential to be a great stint in the studio. You just have to open the door and walk into the room.

I asked God if it was okay to be melodramatic

and she said yes

I asked her if it was okay to be short

and she said it sure is

I asked her if I could wear nail polish

or not wear nail polish

and she said honey

she calls me that sometimes

she said you can do just exactly

what you want to

Thanks God I said

And is it even okay if I don't paragraph

my letters

Sweetcakes God said

who knows where she picked that up

what I'm telling you is

Yes Yes Yes

◈　　Kaylin Haught

OBSTACLES TO WORKING

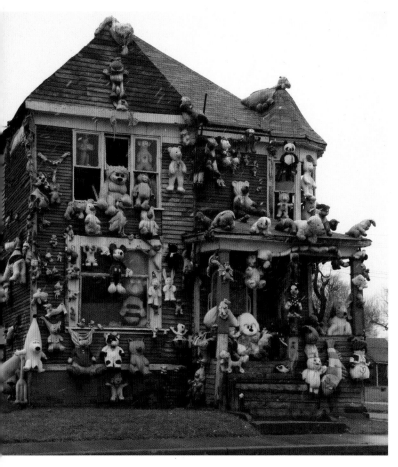

Tyree Guyton's Heidelberg Project is a contemporary rebel success story.

Here are obstacles that keep people from going to the studio, not an exhaustive list by any stretch, but a few of these will probably resonate:

» Not having enough time: "I've only got fifteen minutes (an hour, the morning, an hour after dinner) and I won't get anything done in that much time, so why bother?"

» Having too much time: If you have loads of time it's harder to discipline yourself to go into the studio and begin. There isn't any sense of urgency, so time fritters away.

» No clear action plan: If you don't anticipate how you'll spend the time, it's hard to be directed or enthusiastic about how to spend the time.

» Fear of failure: "What if I spend all that time in there and hate what I did? It will be a waste of time."

» Fear of success: "What if I make something great, I get into a show and then I win an award and my whole life shifts?" We have an amazing capacity as humans to turn something really good into something potentially bad. That is, if I'm a success, my friends won't like me anymore or (fill in the blank). If this resonates with you, get a reality check. Don't you deserve a life populated by people who support you through both failure and success?

» "I can't afford/don't know where to get/don't know what I need." This refers to materials and supplies. It's an easy problem to solve as long as you quit feeling sorry and stuck and do a little research. Don't you really want to do this?

Now let's talk about Tyree Guyton and the Heidelberg Project. Twenty-seven years ago, Guyton co-opted a couple of houses on Detroit's east side. Using a variety of discarded objects, he proceeded to turn two blocks of abandoned houses into the Heidelberg Project—recognized around the world for demonstrating the power of creativity to change lives. Several houses were set on fire by arsonists (some rumored to have been set by the city). Guyton and project participants never gave up. Their passionate desire to reclaim forgotten neighborhoods engages school children, patrons and residents.

Tyree Guyton is a Rebel Artist to the extreme. Most of us will never be that extreme and we don't need to be. But most of us could benefit from embracing and encouraging the Rebel Artist part of ourselves. We've all got one. Human beings are hardwired with a DNA strand of rebel personality because it assisted our ancestors' survival against massive environmental and physical odds. If you didn't question the world around you—on the tundra or in the jungle—there was a good chance you were self-selected out. Rebelliousness was distilled into us as the species evolved.

There's another aspect of the Rebel Artist to consider. Let's talk about archetypes. Psychologist Carl Jung described archetypes as universal patterns of human behavior, located in the human collective unconscious.

Caroline Myss expanded Jung's original precepts in her contemporary writings.

Archetypes are symbolic patterns we recognize in each other all the time. We use terms like "Earth Mother" or say someone is a "prince of a guy." The terms are so universal, they are a sort of shorthand for behavior, even when we don't consciously think about it. There are hundreds of archetypes.

Using archetypal language allows us to take an impersonal, symbolic look at ourselves, and that can help us become better artists!

Back to the Rebel archetype. We already have a rebellious streak because of our evolutionary wiring. Add an option to engage the Rebel archetype actively in order to strengthen commitment to making, and you are working with powerful energy. Your Rebel will help protect studio time and further strength training by supporting your questioning of the world around you.

The Heidelberg Project is alive with color, pattern and reuse of cast-off materials.

As with all things, this takes practice. Rebelling might be in our DNA but that doesn't mean we're always comfortable with it. Being a team player, "fitting in," these community-building postures encourage sublimation of rebellious inclinations. But in the studio you can't afford to sit back or lay low. Your Rebel Artist knows you have a right to studio time and gives you permission to break the rules.

But first you have to notice the rules as they apply to you, rules you've embraced, consciously or unconsciously, that curtail your highest potential in the studio. Only you can actively list the rules of your life. A partner might be able to help, and that would be good because then you would both be more conscious of what your agreed-upon rules are.

Take something simple like doing the dishes. Is there a rule in your house (or head) that the dishes must be done by a certain time, like right after the meal? Are there rules about making the bed or folding the laundry? Everyone has house rules and also personal rules. Some rules are not negotiable like "I am definitely going to clean out the cat box when I wake up in the morning or I'll pay."

However, loads of rules could stand to be broken or could at least be negotiated. Inventory the vast set of rules functioning in your life, and decide which ones are worth it and which ones are total time wasters. If there's a rule you abide by every day, but you could let it go one day a week, think it over. Your Rebel Artist needs more studio time.

CHECK IT OUT

We haven't even started talking about art rules yet. Here are a few familiar rules of art and making:

- ◈ You don't know how to draw unless you take a class.

- ◈ Your quilting stitches have to be twelve to the inch or you'll burn in Hell.

- ◈ The art police rule. They are watching you.

- ◈ You should always bind the edges of a quilt.

- ◈ You should never bind the edges of a quilt.

- ◈ Work should be archival so it will never age, fall apart or deconstruct. (We should all be so archival.)

- ◈ You can't call yourself an artist unless you've got a lot of nerve. Someone else has to bestow the title upon you.

There are scads of art rules. Contemplate a few to which you might have fallen prey. Contemplate the bill of bad goods you've been sold. Call out your righteous Rebel, and vow to break a few rules. It's good for your creative stamina.

THE REBELLIOUS EXPANDED SQUARE

CROSS-TRAINING EXERCISE

The original expanded square exercise was introduced in a great little book titled *Notan: The Dark-Light Principle of Design* by Dorr Bothwell and Marlys Mayfield (Dover, 1991). The expanded square is only one of numerous exercises in the book, designed to give the reader/artist a better understanding of interactions of positive and negative space. There's a good chance you're already familiar with this exercise because the book has been around awhile. But in case the expanded square exercise is new to you, here are the basic rules:

1. Don't cut off the corners. Keep the integrity of the square shape.

2. No pieces can be discarded. Every piece cut away from the square needs to be glued down in its opposing (mirror image) position on the paper.

3. Cutting through the center isn't allowed because then you have to figure out which side to paste the cutout shape on. Avoid cutting through the center.

If you've never made an expanded square, make a few according to the rules before moving to Part 2, the real point of this lesson, which is to break rules by abandoning rules!

PART 1: HOW TO MAKE AN EXPANDED SQUARE

1 CUT SEVERAL SQUARES

Cut several 5" (13cm) squares from black paper. Smaller squares are hard to use; bigger ones may expand beyond the white paper background. The squares should be as perfectly square as possible.

2 CUT OUT SHAPES

Begin cutting shapes from the sides of the square. Every time a shape is cut out of the square, it must be glued down as the mirror image on the side from which it was cut. The basic idea is to cut out the shape, flip it over/out so it mirrors the cutout space, then glue it down. There are two classic approaches to creating an expanded square: symmetrical or asymmetrical. See the examples here to get the hang of this.

The design can be cut symmetrically, which means the same shape is cut out of each of the four sides.

The design may also be cut asymmetrically, where the four sides are different from each other. If even one side varies from the other three, the square is considered asymmetrical.

Sandy Kunkle played with turning the square into a circle.

PART 2: HOW TO BREAK THE EXPANDED SQUARE RULES

Do you have memories of being told you weren't supposed to do something and the next thought in your head was *Why not?* or even *Oh, yeah?* That's the rebel in you. If that thought has never in your life occurred to you, this will be good practice because artists benefit from confronting rules or ideas that are itching to be challenged.

In reality, every idea is itching to be challenged. That's why we have hundreds of schools of thought about how to make art, not to mention science, religion, politics and cooking.

Right now it's time to challenge the rules of the expanded square. Want to cut off the corners? Go for it. Want to cut through the middle? Yippee! But there's so much more. Review the basic strategy of the expanded square above, then start asking questions and writing ideas in your notebook. Lists are good.

A few questions to get this started:
 » How much of the square can you remove before the visual reference to the square disappears? If the square isn't there anymore, do you like the abstraction you've created?
 » What could a square be made from besides paper?
 » What would happen if the square was dimensional?
 » What if the shapes cut from the square told a story or were a form of poetry? What would that look like?
 » What could you do with the pieces that were removed or left over after deconstructing it?
 » What have you thought of that hasn't occurred to me? What will you think of if you just start cutting and playing and see where it leads?

Do jump in without overthinking. The first piece is rarely the masterpiece. Do a square every morning for a week. Or do several in a sitting and see where stream of consciousness leads.

CHECK IT OUT

As you work through this exercise, be mindful of your thoughts. Are you thinking of other art rules you haven't ever challenged? In addition to blowing up the square maybe there are other practices you could revisit. Making a list of rule breakers you'd like to try is a start. Get some writing going.

One question we don't think about asking is "why?" Other design books often encourage people to ask "what if?", but that's not the only question. Asking "why?" is critical because the answer may prove a method or practice or product is outmoded. It doesn't need to be done that way anymore. There are better products or different goals.

It's good to be a skeptical, rebel participant in Life. Try out as many Rebel Artist ideas as you can because the proof is in the doing. We can talk all day, theorizing whether this or that will work, what color to use, is the paper the right kind . . . but in the end, the only way we'll know for sure is to do it. So blow up a few expanded squares, then look around to see what might be next. Keep your Rebel Artist riding shotgun and trust wherever it leads.

Carol Wiebe made stencils instead of expanded squares and used them to create an artist's journal.

I loved the rebellious square exercises. But I have to make a confession, Jane. There was no way I was going to do all that cutting; I had too many art projects on the go. I love cutting paper, but having designed quite a few stencils, which require the same kind of positive/negative eye needed for this exercise, I did the exercise in Adobe Photoshop Elements. No one made accusations, and I thought to myself, *I really am rebellious, tee hee. Perhaps someone else can send you the "real thing."* I ended up making stencils from my rebellious square designs. I think they are an art form in their own right!

❖ Carol Wiebe

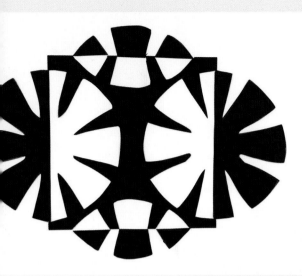

Mary Ann Ashford made her expanded square and then translated it into a pattern she had printed digitally on cloth.

My insights from this exercise: It's the type of rules I am asked to follow that create my obstacles. I figured for me there are two types: doctrinaire and meditative. The doctrinaire rules are critical and inflicted from the outside. (Major obstacle builders for me.) Meditative rules are uncritical and help me to center within. This exercise has helped me understand my rebellious relationship with doctrinaire rules and how that relationship has had a negative effect on my creative endeavors. That understanding is very revealing. And it inspires me to approach my work with a new mind-set.

❖ Mary Ann Ashford

Mary Elmusa started with one image, expanding and deconstructing until she'd created a related series.

I used to be a super awesome, kick-ass rebel. But in reflection I've realized I've gotten a bit lazy and entitled, like a Southern belle sitting on the verandah waiting for her next mint julep delivery. I tried the expanding square assignment and found many unspoken, unwritten rules lurking just beneath the surface. Rules about perfection and failure, controlling chaos, knowing everything, knowing nothing, what's important and what's not. The voice that says you can go out to your studio after you've made the bed, cleaned the house, planned the meals . . . (God knows my husband, Bruce, is a great cook, so it's all my stuff . . .) walked the dog It's only a hobby, after all. One of the hardest parts of this week was owning that voice.

There was something in my weak little rebel's voice that reminded me about daring, courage and being true to myself. I get choked up when I realize how much I've missed her.

So no pictures of my expanding squares. Instead I've played in my studio every day this week, and I'm only slightly guilty about the state of the house.

❖ Deborah Franzini

This has been a year of major changes and losses for me. I find I cannot continue to work in the same ways as before. The Notan assignment for me was based on literally dissecting/cutting the typed word *sad* with an emphasis on preserving the negative or empty spaces. I then transferred the spaces to the black paper and expanded outside the square. As related to the losses I've dealt with lately, I wanted to distill, to winnow away, to make the majority of the image gradually disappear, as shown in the series of images. What remains would represent the succinctly empty but actively remaining condition.

❖ Mary Elmusa

Jeanette Davis expanded up and away from the flat plane by turning her square into a sculptural box.

This exercise definitely contributed to spending more time in the studio. One of the new rules I made for myself is to shut the door when I'm in the studio. Duh! This simple solution to an old problem came to me out of the blue while I was trying to figure out what to do with my attempt at making a 3-D something-or-other from the squares. It was a sudden and emphatic thought, and I quote: "Shut the damn door!" A message from the universe, from my Rebel Artist or from my nutty archetype?

❖ Jeannette Davis

CONCLUSION

When an activity is new, the doing can be exciting or intimidating. Being present and witness to your reactions is its own rebellious act! So keep going with this exercise if it's new and explore it fully.

One goal is to know ourselves better. There's a reason that when we talk about archetypes, we talk about a house of twelve. Without knowing much about that symbolic language, you can know intuitively which part of yourself is operating in any given circumstance. We all have several selves. Sometimes your secure part takes over. Sometimes the less secure part is operating. Having figured out my twelve archetypes, I know when my Rebel should lay low and my Guide should take over! Sometimes it's my Damsel that's reacting to the situation, and then my Rebel/Gambler needs to step in. I like being able to describe and understand myself using these terms, and doing so supports the basic idea we worked with in this chapter. The Rebel in each of us needs to be cultivated but in a way that serves our highest purpose. That is, to become the centered, self-actualized Artist we are each capable of becoming.

Overcoming Stumbling Blocks,
PART II

CREATIVE STAMINA

Building creative stamina takes time. It's supported by several practices: writing for clarity and managing studio time; acknowledging the unseen rules we've imposed on ourselves and questioning them; casting off rules that no longer serve a purpose; cultivating the Rebel Artist, who stands vigilant in defense of studio time, the right to it and the right use of it.

Dropping rules that aren't working, or rules stifling your time, is the first step. I hope you recently left the bed unmade at least once. And allowed dishes to baste in a sink of hot water while you rattled around in your studio. Or did a great job cleaning up if that's what was needed!

In this chapter, we consider obstacles to making generated by what I call the Committee. It's important to know who's on your Committee, and we've all got one!

This being human is a guest house.
Every morning a new arrival.
A joy, a depression, a meanness,
some momentary awareness
comes as an unexpected visitor.
Welcome and entertain them all!
Even if they are a crowd of sorrows,
who violently sweep your house
empty of its furniture,
still, treat each guest honorably.
He may be clearing you out
for some new delight.
The dark thought, the shame, the malice.
meet them at the door laughing
and invite them in.
Be grateful for whatever comes.
Because each has been sent
as a guide from beyond.

◆　Jalāl ud-Dīn Rūmi
translation by Coleman Barks

THE COMMITTEE,
YOUR CHAKRAS AND THE TRIBE

Dismantling the Committee is key to strengthening your Artist Self, and nobody gets hurt. Some people see the faces of their Committee members while others hear their voices.

Imagine yourself in the studio, doing whatever you do to make art. Gradually you start to feel anxious, like you aren't good enough, or you're bound to fail, or you should just quit right now while you are ahead. They are the voices or faces of people who were relentlessly judgmental of you in the past or of people you really want to please and impress. They could be your parents or a spouse, a sibling or a teacher. They could be somebody who's dead but could just as well be someone who's still alive and kicking. They could be someone you don't even know personally.

I see faces. The day it dawned on me that I had a Committee, I wanted to laugh out loud it seemed so absurd. Then I wanted to cry. My Committee members were my father, two famous artists I know personally and the president of an organization I'd belonged to for over twenty years. It was weird but true. Working along in the studio, feeling just fine . . . and then progress would slow, even get a bit rocky. As soon as it did, one of those faces would pop into my head with a very disapproving look indeed. I knew what they were thinking without even having to ask.

Oh, my. That doesn't look good.

Gee, couldn't you have done a better job than that?

In order to understand where the Committee comes from, let's talk about human history, evolution and, believe it or not, the energetic system known as *chakras*.

Originally arising from Hindu metaphysical tradition, chakras are defined as centers of life force or vital energy in the human body. Contemporary theorists like Dr. Caroline Myss suggest that chakras are energetic centers within our bodies, each of the seven points related to energetic development. Fundamental human issues—safety and security—are represented by the first chakra, shown in red. As we mature mentally, physically and energetically, we embrace the other chakras. Seventh-chakra energy—at the top of our heads—is our connection to the Universe, The Great Mother, God, Allah, whatever works for you.

We're only beginning to recognize the relationships between human physical, mental and energetic (or spiritual) systems. But everything evolves and builds on everything else, and how life is explained to us depends on what culture we grow up in.

Take Western culture, for example. In 1943, psychologist Abraham Maslow described what he called the Hierarchy of Needs, which included physiological needs at the basic, fundamental level of the pyramid as he modeled it. As those survival needs are met, we work at fulfilling higher-level needs and eventually, if we pay attention and keep plowing along, we achieve self-actualization. His system, along with the chakras and a variety of other theories, concur that human beings really do want to be better and happier, kinder and more creative.

It's very encouraging!

This is where chakras and the Committee converge. As infants and children we are defenseless. We need adults in order to survive. Our fundamental needs are met at the first chakra level by our parents, extended families and community. Our energetic need is to belong, to be cared for and to be loved. In this scenario the Tribe is a very good thing. Perhaps you've been in a setting where someone referred happily to being part of a Tribe—a community of people who share a passion for the same thing. It's a wonderful feeling to connect to your Tribe.

However, the Tribe has a shadow side, a side that is activated when you veer from the standards of the Tribe or actually threaten the Tribe's status quo.

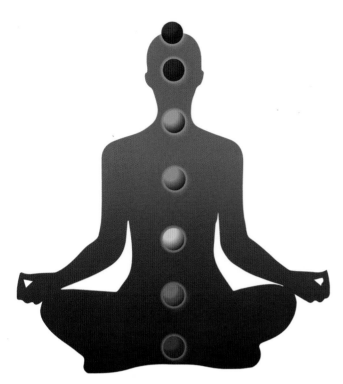

Map of the seven chakras. Illustration by K Wayne Harms

Remember, the evolutionary purpose of the Tribe was to make sure your ancestors survived by being ready to act at a moment's notice. If the Tribe leader said, "Let's get packing; it's time to flee," you threw your stuff in your rucksack and fled. People stuck together. There wasn't room for an individual rebel who might slow the Tribe down and cause the group's demise. Individual rebelling was frowned upon.

We no longer need to be part of a tribe to survive, but the tribal desire to keep everyone in line still lurks in our DNA. Tribe members frequently perceive it as a threat if someone challenges the system, whether it's deliberately rebellious or not.

About a year after I left the Southwest Craft Center (where I chaired the Surface Design Studio) to become a freelance artist, I went to an art opening in San Antonio. I saw two former board members across the room, so I went over to say hello. One looked me squarely in the eye when I reminded her of my name, and said, "Oh yes, I remember you. You got too big for your britches."

Hmmm. I nodded politely, but when I got to the car I cried buckets before I could pull myself together enough to drive home.

The Tribe may be lovey-dovey when everyone is on the same page but veer off into new territory, and you will likely encounter disapproval, discomfort and sometimes downright meanness. And that's how some members of your Tribe morph into your Committee.

This is important: *Committee members don't put themselves on your Committee. You* put them there. In fact, most of the members of your Committee might be hurt or shocked if they knew they had spots at the table. These are not necessarily people who dislike you. My father loved me. He did the best parenting job he could do with what he had. It wasn't perfect. Occasionally he was very insensitive to my need for approval and dished out criticism instead. But it was my desire to please him that put him on my Committee. People who land on your Committee may have been mean to you or dismissive. It happens; life sucks sometimes. But you're still the one who abdicated your power by putting them there.

And it's just as true that Committee members may not even be aware of you. The other three members on my Committee don't care about me or what I do. My admiration of them translated into a fear that they wouldn't like my artwork if they saw it. That's about me, not them. When I realized this, it was the first step to dismantling my Committee, which is what we have to do if we are going to take ultimate responsibility for what we make. No one else can dismantle your Committee for you. You have to do it yourself. Then you are free to love what you do. No more faces. No more voices.

CHECK IT OUT

Two goals here:

◈ Clarity comes from recognizing the common error we make—of believing we know what people are thinking and how they are judging us. You don't really know, do you? Stop projecting your own insecurities onto other people. Stay in present time.

◈ It's a relief to realize someone really *is* judging us. At least the elephant is out in the room, so it can be dealt with and eventually dismissed. Even if you never confront the real person, at least you are clear about what's happening. And then you are OK.

DISMANTLING THE COMMITTEE

CROSS-TRAINING EXERCISE

Dismantling the Committee happens in this order: First recognize your Committee members by paying attention to the voices or the faces that pop up when you're in the studio and it isn't going well. Then think about each person and use writing as the tool to unlock the reasons behind each member's presence. Next, write whatever needs to be written in order to dismiss the member from the table:

» Maybe you have to tell him or her off.

» Maybe you have to let go gently because the person's presence says more about the work you need to do than it does about him or her. This can feel sad but also be a relief.

» Sometimes you just have to write down a few reasons a Committee member is in the room and laugh like crazy. Because the whole thing *is* crazy and you didn't realize it until now.

Buddhists talk about the Noble Friend, a person you believe holds a key to something important to you, but who never gives you what you want. It would be easy to think this is an unfriendly way to behave, but dig a little deeper. The Noble Friend actually offers you a gift because when you can't easily get what you want from someone or a situation in life, you are tempered by frustration. And just like tempered steel, you grow stronger.

So you see, this is a rich process. On one hand you have the chance to blast someone who's been on the Committee if you want to or need to. On the other hand, you have the opportunity for great personal clarity and tenderness with this process. It might even be an opportunity to forgive, and that's absolutely precious. In any event, the end goal is to clear out the mental debris that gets in the way of working, call upon the Rebel Artist to protect studio time, then get going, feeling a little lighter on your artist feet.

WHAT TO GATHER

◈ favorite writing implement

◈ something to write on (journal or loose paper)

Remember the value of writing in addition to thinking. This is not stuff you can keep in your head; it's helpful to write it down; it's easier to track ideas and there's a record in case you want to review later. Here are a few steps to get started:

1 NAME THE COMMITTEE MEMBER

If you are uncomfortable putting a whole name on paper, use initials. What difference does it make as long as you know who it is?

2 WRITE A LETTER

The next strategy is personal. You may want to write a letter to the person outlining why he/she is on the Committee and why you are removing him/her. This is not a letter you send. As a matter of fact, you may decide to burn the letter later. Burning is always a release!

If the letter-writing strategy doesn't appeal to you, make a list or just do a little stream-of-consciousness writing—whatever pops into your head. Just write it down. This is not a time for judging or editing. If there is a reason to edit, it will come later, after the exercise is completed.

3 QUESTION MEMBERS' ASSIGNMENTS

The other part of the writing is the opportunity to think about the Committee members from a broader perspective. Why do the people who end up on our Committees land there? The whole idea

of the Committee is symbolic. What are your real fears? Because that's what the Committee members represent: an obstacle to building creative stamina. One more thing that gets in the way of being in the studio regularly and practicing. A block to strength training.

Knowing others is intelligence;

knowing yourself is true wisdom.

Mastering others is strength;

mastering yourself is true power.

◈　Tao Te Ching
　　translation by Stephen Mitchell

CHECK IT OUT

You can have a little fun with this. It doesn't all need to be heavy and serious. I made a collage of my Committee members by cutting and pasting their heads onto a stock photo I pulled from the Internet. It makes me laugh and reminds me of how crazy the Committee is in the first place.

Or you can make something that represents your newly won freedom from your Committee. What would it be? Something you'll keep as a reminder or something you'll burn or throw away?

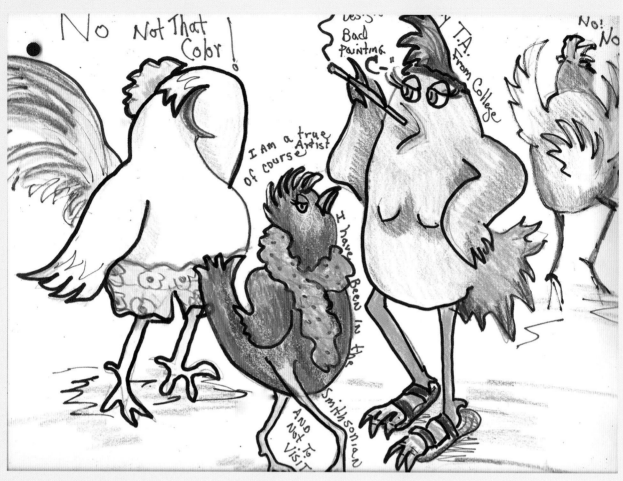

Judy Cook played with the ideas about the Committee she saw in her mind's eye!

Here is a sketch of my Committee. I hear their voices. One who likes to pop up is a TA from basic design class in college. "Good design, bad painting, C-minus." Another member of the Committee stands behind my shoulder when I am doing watercolors and tells me my mistakes. The third Committee member is an excellent felt maker who has shown her work in the Smithsonian. She isn't critical; I'm just in awe of her. She reminds me that if I like one square inch of what I'm doing, I'm on the right track. The fourth critic running away in distress is a composite of all of the rest: my mom who liked to point out little things, my brother—I don't know why—and another guy I will leaved unnamed. He likes to tell me my work is nice but I will never make a living at it.

I listen to audiobooks when I'm in my studio. It gets me out there instead of in the house with my nose in a book, plus it gives the Committee something to do. They like stories and leave me alone.

❖ Judy Cook

As I readied a quilt for our local guild show, a woman in the guild whom I had never met tried very hard to get on the Committee. As I unpacked my quilt, she walked up, pointed at it and asked, "What's that?"

"What's what?" I replied.

"What's that?" she reiterated, like it was some despicable piece of cloth.

"It's an art quilt."

"I don't get it." She sneered and walked away.

Gwen Hendrix was surprised to find out this piece (Luminayre, 2013), which another artist had dismissed, won an award at the exhibit where each was displaying work.

"Okay," I said to myself, quietly.

Later, I stood near my quilt when the judges awarded ribbons. I watched in awe as a blue ribbon was pinned to my quilt. It had won the Art Quilt/Pictorial Small Category. How surreal!

Since this was my first art quilt, my first guild show and first judged show, that person could have done real damage. Thankfully, years before I learned to silence the Committee. I was helped by a letter from my aunt, who is a painter.

In the letter, she said that for her, it was "all about the process of making the work, not the results. Make your work and trust to keep on making it, in order to get to whatever the next step is. Don't skip any of it.

"Remember, it doesn't matter what others think, whether work is accepted or rejected in shows, by friends, by peers, by galleries. What does matter is having the incentive and desire to do the work, to move forward and allow the work to lead the way—not the brain or voices of others."

I decided right then to focus on the process of doing the work. Period.

The Committee of the Masses was dissolved.

❖ Gwen Hendrix

Committee
Pippa Drew, 2014
5" × 8" (12cm ×20cm)
Black marker on inkjet print

My Committee is a moveable faceless crowd. However, I've identified four familiars from my past: Aunt, Father and an art professor as well as a random male friend close to my first husband—arbitrary, but vaguely representative of teenagers and parents from my hometown.

My father was a man who kept himself apart. When I was two, he and my mother divorced, then he mourned being separated from his kids. A classical archeologist, Philip traveled to Greece and Rome often. Like the three kings in the Christmas carol, he brought us exquisite gifts from afar. At the end, he forgot everything including any of the time we'd spent together. Alzheimer's erased these few histories long before his final breath. I never had his approval and never will. I don't think I was anyone he could understand although he seemed to have a distant love for his kids. Love burned us, so I wrote him a note and burned the note, to leave an air pocket for myself—so I could breathe before I burn away.

❖ Pippa Drew

I had so much fun with this. It was delightful to turn the tables on my Committee. They are always toying with my emotions and amusing themselves at my expense.

I opened a few apps on my iPad that distort photos, and I made faces representing the members of my Committee. This was perfect because I know their expressions so well, and in the final analysis, there is no one on that Committee except me.

Everyone would reject you if you expressed what is really inside you.

No one can make a living as an artist—unless they are a genius. You are not a genius.

People are just too polite to tell you what they really think.

I see mistakes—LOTS of mistakes.

You want to enter *your* work in *that* show?

If you do that, they'll all think you're too big for your britches.

Carol Wiebe's set of Committee Trading Cards sums up all of the critics—real or imagined—who occupy our thoughts when we work.

I turned the faces into Committee Trading Cards. I first designed a back for the cards (wagging finger, big mouth yakking, judging eyes). Then I added a phrase that could be what the Committee member is saying. Has said. Will say? (Not if I have my way.)

Hey, join me! Make some cards of your own. We can trade them. We can all hoot with laughter at the Committee's expense. Woohoo!

❖ Carol Wiebe

CONCLUSION

The Committee never disbands completely. Is there a Committee Hall of Fame? I'd love to be in a retreat center with you where we could split into groups, write skits about the Committee and act them out. That would be good for a laugh and probably a cry.

Acknowledging the power of exterior forces is half the battle in defusing them. *You* have the inalienable right to choose how to think about everything that happens to you. Harness that strength and jump into our next topic: the power of limitations.

The Power of Limitations

HAIKU

The Japanese poetry form haiku is an example of working within limitations. Traditional haiku were related to a season, or the natural world, and were referred to as a "fixed form" because the structure always consisted of seventeen sound units.

Western writers substituted syllables for sound units. A fixed-form haiku is composed of three lines: a first line of five syllables, a second line of seven syllables and a third line of five syllables. Contemporary free-form haiku may abandon the seventeen-syllable structure, but the preferred emphasis on everyday objects or activities remains.

We don't always willingly impose limitations on ourselves; sometimes they're imposed by life's circumstances. It's not always a pretty picture. Sometimes it's rough.

As artists, one of the paradoxes we encounter is a positive experience of self-imposed limits. In the studio, "centering" is grounded by setting limitations. Identifying parameters around process or materials may feel limiting, but in fact it frees you to concentrate on making and meaning, and teaches a little about balancing work and play.

Marry work and play—

first one and then another

Surprise! Playing works!

Some poor villages
lack fresh fish or flowers.
All can share this moon.

◈ Saikaku
1642–1693

Since my house burned down
I now own a better view
of the rising moon.

◈ Masahide
1657–1723

USE WHAT YOU'VE GOT

I used to spend way too much time shopping for project supplies. There was always one more elusive something I needed. Another chapter of the story? Being at markets, trade shows or visiting a new city, which inevitably exposed me to a load of fresh stuff I just knew I had to have. Load up the suitcase. Take it all home. No questions asked. It's a good thing I wasn't driving. At least I was limited to a suitcase.

The day came when my studio needed to be cleared to prepare for a badly needed paint job. I was confronted with the reality of my cavalier acquisition style. Where would I stash all that stuff during the painting, and more importantly, why did I buy it in the first place?

A careful examination was revelatory. I would never use half the stuff I'd bought. The shiny, silky, oddball stuff on the shelf was solid proof of how easily I am distracted. It represented the seduction of possibility, from which emerged two of my most important and rigorous personal studio rules:

1. Something comes in; something goes out.

2. Use what's here.

SOMETHING COMES IN; SOMETHING GOES OUT

Of course rules are meant to be challenged and broken, but you have to start somewhere. These two rules function as the standard from which all permitted variances spring. I dye silk fabric, so when a friend closed her studio and offered me her fabric, of course I said, "Yes!"

On the other hand, I no longer—out of a sense of conflicted gratitude and willing helpfulness—accept just any fabric offered me. If it's a fabric I'll never use, it would only take up space on a good shelf. If I later realize I passed up a good thing—as sometimes happens when you have just given away a ratty old coat, and then you are invited on a hayride, and you really need a ratty old coat—well, I'll chalk it up to experience and figure something out. Once a friend offered a bolt of cheap gold lamé left over from making costumes, and I turned it down. A month later, during a midnight brainstorm, I saw how to create sparkle behind a panel of sheer silk. Use

gold lamé! Yikes. Too late. But the fabric store was open the next day, and guess what? They sold gold lamé.

Which brings me to an observation of human behavior: We always worry there won't be enough. Somehow we'll be the ones who are left out. I guess it's a quirk of human nature. A friend finally admitted to a hoarding problem when she ordered a third storage unit for the side yard. She couldn't go upstairs; the second floor was packed with clothes, shoes and other paraphernalia. Things were crazy out of control, and she knew it.

Most of us don't have it that bad, but we've still got a bit of hoarder in us. Maybe it's a garage crowded with bags of blue jeans you bought cheap, thinking you might make some denim quilts. Seemed like a good idea at the time. Fifteen years ago.

Or maybe it's dress patterns you're keeping because someday you might sew again. Or tubes of paints saved by default because you no longer paint in oil but switched to watercolor—six years ago.

We're so afraid we'll need something in the Never Neverland of later, we gradually pile stuff up—just in case—until we can't find a path to the door. If this isn't literal for you, it might be symbolic. If your head is crowded with projects (especially unfinished ones), you don't have enough open terrain to graze new ideas, which need space. Clear literal closets, shelves and drawers, and mental spaciousness accompanies the clearing. The open prairie in your head comes back. Ready for grazing.

If you're still struggling with attachment issues to unused stuff, consider this: Someone else will be really lucky to get your castoffs. Which is related to a physics rule I vaguely recall, stating that matter never disappears; it just changes form (or ownership). Your perfectly good stuff, for which you have no plans, could delight someone who currently has plans but no stuff. Employed properly, it's a divine circle. That's why we have online giveaways and sales sites. They allow us to discard stuff in addition to allowing us to acquire stuff! And clearly demonstrate the second rule.

Consider limiting a variation such as color when you plan a series.

USE WHAT'S HERE

Use what's here. Using supplies you already have in the studio means you must actually analyze what you've got and strategize how to put it to good use. But a secondary benefit is that you actually stay in touch with your holdings. The contents of bins and boxes don't fall off the mental radar because you haven't inventoried regularly.

When you are in touch with what you have, you are also in touch with what you don't have, so a clearer sense of what is needed transpires. Mindful acquisition is good. Remember, this is never about being a martyr where ownership of supplies is concerned. If you need something and are using whatever it is often, plenty of it should be available. That's just good studio practice.

TWO OTHER BENEFITS WORTH CONSIDERING

First, intentionally choosing to use what's in the studio keeps you in the studio. Fewer spurts of jumping to run out and shop. That's not to say a day won't come when red paint is required—just the right color of red paint, for that matter—and it's not on the shelf. But that's probably an exception. We're talking about a strength-training practice that keeps you in the studio—when it would be easier to avoid challenging or scary *can I do this?* work—by defaulting to shopping mode. Please don't.

Because you know as well as I do what a terrible feeling it is when you're shopping or lunching, and you *know* the real reason you're there is because you're avoiding studio time.

The second benefit is the potential for recycling, recalculating and re-visioning. Improvising! Take a good, long look at the variety of supplies and inventory you already own. Write a big sign that says "Use What's Here" and put it on the studio wall. It's a reminder to consider using or transforming something you already have before rushing out to spend money. Not everything becomes something better, or something else. But it happens. And it represents a chance to alter half-finished work and/or failed pieces and possibly cast them in a new and potentially successful light.

LIMITING VARIABLES

Tools and Materials - Monitoring additions to your stash and consistently using available supplies strengthens your ability to focus. Engaging the Rebel Artist to protect studio time secures the spaciousness you need in order to work. Writing down ideas, realizations and plans for new pieces keeps thoughts organized. These strategies are the foundation of creative stamina.

Consider limiting variables for a specific project or series. For example, stick to one color palette across a series as a way of unifying the set. Work achromatically—that is, without color—use only white, black and gray. See what happens when the seduction of color is eliminated. Or choose a set of tools and don't deviate from using them. There are a variety of straightforward ways to shape work intentionally by choosing the tools, processes and materials used to create it.

Content - Shaping content is as important as choosing specific processes or tools, but it requires planning at another level. Choosing tools or colors from the supplies on hand, or buying a set of new paints at the start of a series is a relatively simple process. Choosing and developing content takes time—and some effort—in order to be satisfying. Think of it as a scavenger hunt. Use writing to facilitate the hunting and to keep track of great ideas.

THE SCAVENGER HUNT APPROACH

Scavenger hunt planning is available to anyone who will do the work. Subject matter is as varied as we are. And working with content *first* is actually freeing, although most people haven't thought about it that way. We're wary of planning. We think it will be hard. We say we just want to play with techniques, but that's where we get hung up. Lots of tools and techniques, but what to do with them? Where to begin? What's missing?

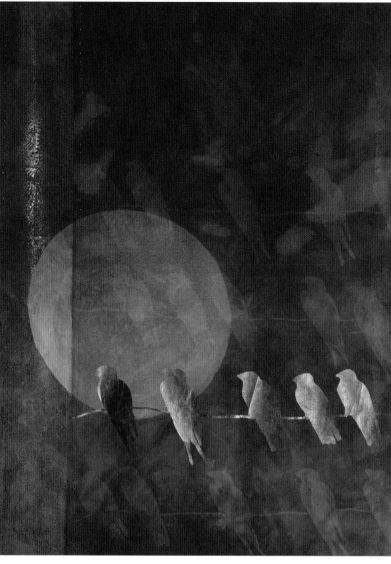

Choir
Jane Dunnewold, 2005
80" × 24" (203cm × 61cm)
Silk organza and broadcloth

Content. Content can be color or form. If playing with those is what appeals to you, there isn't a problem. But if you sit at the studio table staring aimlessly out the window with no clue about where to begin, yet you really want to work, maybe what you're lacking is content. Figure out what you care about—flowers, color, world peace, architectural details, whatever—then let that caring drive whatever you make.

Initiating work by identifying content first provides direction that doesn't exist if you're just working from the toolbox. Intentional planning turns studio time into a playdate because the groundwork needed to drive content is laid in advance by acquiring or creating whatever tools are needed. You're free to play with your tools and see where content takes you. Surprising it could be so easy. But it is. Look around. Figure out what you love. Write it down. Get started.

CHECK IT OUT

I use the scavenger hunt approach whenever I get an idea for a new series. It always works! An idea occurs to me and sticks around long enough to gain traction. Consider the idea of "boundaries," the theme of a series I created.

Free association allows me to delve deeper into the topic. It works like this:

1. Write a word (I chose *boundaries*) at the top of a page of paper.

2. Set the timer for two minutes.

3. Write down whatever words come to mind during that time. Do not edit. Just write.

This list making produces a wealth of raw material, words that are already visual images and words with potential to take content deeper.

I move to the acquisition of images based on the free-association list. "Boundaries" translates into maps, fences, birds on a wire, fish swimming in schools, migration patterns and military intervention. Where I take those associations is up to me, but the remarkable process of "mining for meaning" has begun.

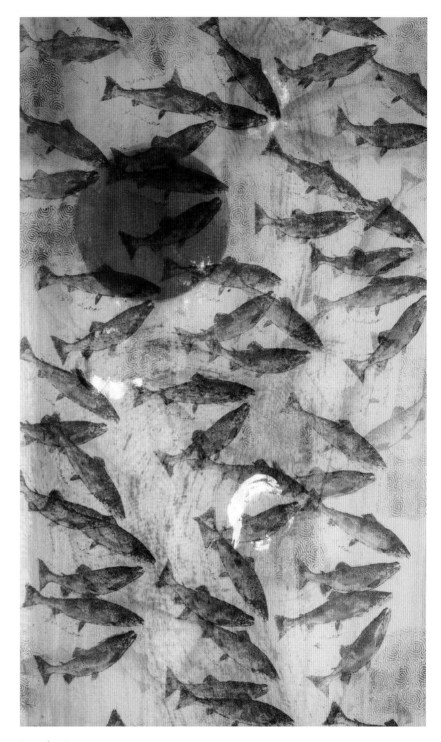

Paradise I
Jane Dunnewold, 2005
80" × 30" (203cm × 76cm)
Silk organza and broadcloth

EXPLORING LIMITATIONS

CROSS-TRAINING EXERCISE

It isn't going to be any surprise that in determining where to set limitations, the first thing you could consider doing is clearing out the studio. Inventory what you've got on hand. This may be daunting. But you can cut a deal with yourself to get the process started.

PART 1: EXPLORE THE OPTIONS

» Vow to fill at least one bag with items you no longer need, and give it to a friend, a secondhand store or offer it online. Vow to do this every week for a month or until everything you want to release is gone.

» Organize one area of the studio at a time, whatever that means. Recently I called my sister, who was furiously emptying the kitchen junk drawer. She was in a bad mood, but she knew it would lift when stuff was organized. And she did feel better. So will you. Just do it.

» Consider incorporating my studio rules: One, something comes in; something goes out. Two, use what's here. Write down your interpretation or write your own version of the rules. Remember, no matter how sensible or good a rule is, if it doesn't fit, it's not your rule.

PART 2: WORK WITH IT

Choose from the suggestions below or make up your own project.

» Cut up a piece of art that isn't working or paint out a painting that sucks. Be fearless. How could this get better? Cut up two pieces and put them together. Study the process and write about it. Don't feel guilty if nothing comes of this and you have to throw it out. Sometimes thinking, figuring, failing and refiguring trump finished product.

» Set limitations before you begin. Color? Tools? Size? Materials? Work small so you can see the piece through to completion. Write about it.

» Write several sets of "game plans" featuring a variety of limitations. Put them in a hat. Choose one whenever you need a jump-start. Your Rebel Artist may sneer if you don't like what you drew on any particular day, but at least you'll have something to push against.

» Fast-forward to content. What do you care about? Engage your writer/Artist Self and explore a topic using free association and visual imaging. Plan the tools.

We rowed into fog
and out through fog . . . oh how blue
How bright the wide sea.

◈ Shiki

ARTISTS RESPOND

Sandy Kunkle's art made from materials she already had on hand.

Purging clutter seems to be a major item in my life right now. I am working on both the physical clutter and the emotional clutter. The physical purge is easier since I can clearly see the items that need to be purged. The emotional purge is harder to identify, but what a rewarding experience when my mind bags something and I see it thrown into the trash. Sometimes I am tempted to return it to the person who originally gave it to me, but then I think, *Be a better person than them. Throw it out.*

❖ Linda Dawson

The haiku at the beginning of the essay really spoke to me. The limits were liberating! While I define myself as a fiber artist, I think there may be a poet/author lurking somewhere inside, too. Here are some haiku I wrote:

Limitations help
Inspire greater artwork
Less liberates us.

Hug your artist self
Creative doors then open.
Art passion is released.

The soul is nourished
by artistic endeavors
Art is fulfilling.

❖ Louise Bateman

The real clincher of this week's assignment was learning firsthand about the power of limitations. I had an assignment to work in a 12" × 12" (30cm × 30cm) format for our design group. The size was my first limitation. I've probably never done any piece smaller than 3' × 3' (91cm × 91cm). Color and value according to the assignment were my next limitations. And I added a third:

Use only materials I had on hand. I used a piece of inkAID coated gauze that was already printed. I liked it but had not found a way to integrate it into a larger piece. I played instinctively with the gauze and created a piece that I think had just the right bit of mystery.

The power of limitations came to mind again today after I sat in a poorly run meeting that started late and ran forty-five minutes over the stated ending time. My volunteer work is important, but time in my studio is more important. Certainly the reaction to this morning would have been the same with or without strength training, but illuminating my situation and my reaction to it with the power of limitations gives me the courage and permission to make a positive decision for myself.

❖ Sandy Kunkle

Barbara Bushey's art from using what she had on hand.

Another aspect of "Using What You Have"—I resisted the urge to go out and take more photos of cornstalks poking through the snow because I already have hundreds and got to work on a study for a quilt.

❖ Barbara Bushey

Transformation
Deborah Franzini, 2004
(reworked 2015)
Commercial cottons and tulle,
machine pieced, machine quilted

*Deborah Franzini explores the
value of limitations frequently by
making art quilts created from
hundreds of tiny components.
She does this in the secluded
comfort of a small cabin in
Northern California, USA.*

Reliquary
Deborah Franzini, 2015
Various hand-dyed and upholstery
fabrics; machine quilted

This week, using journaling to mine for content was an awesome new idea to me. I'm writing more, and it's both exciting and scary to see what comes up. This morning in my studio, I took an older, completed quilt and sliced it up! I can't wait to see what it becomes now.

❖ Deborah Franzini

Laurie Paolini found freedom with the limitation of starting with gelatin prints she had created previously.

When I started Artist Strength Training, I promised myself I would do the homework, and I've been in the studio every day. I've organized, labeled, hung, filed and inventoried everything. Last weekend after more dawdling, I realized this was *not* the kind of studio time Jane was talking about; I was seriously procrastinating.

Distracting myself
Avoiding art by planning
I am so busted

Bottom line, I am afraid to make art because I don't want to make bad art. Organizing let me hide behind the noble pretense of working. I needed to stop and do the work. Hand-painting has always been my favorite technique, and I rediscovered the meditative feeling I get when I paint on textiles. I am trying to be gentle with myself.

Fearing art mistakes
I let the process unfold
No ugly babies

❖ Tara Alexander

After spending last week crippled with self-doubt, this lesson was just what I needed. I'm not fond of the term *aha moment,* but that's exactly what it was. I started to work, immediately setting limits. I would use some of the gelatin-printed backgrounds I've been afraid to touch for fear of ruining and photos I've been taking of birds at our feeder. I would monoprint, gelatin print and use only materials I had on hand.

Real life called and only tonight did I get back to the project. Because what I was working on was so specific, I knew immediately what to do and getting back to it was easy. This could easily have turned into another abandoned effort.

By setting the parameters up front, I was free to work on the art itself and not the things used to create it.

❖ Laurie Paolini

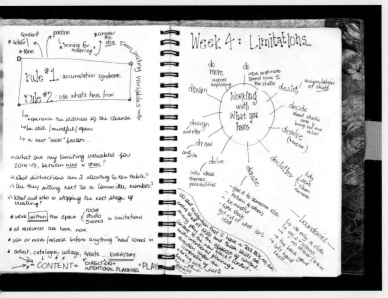
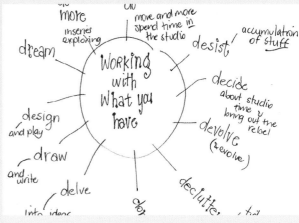

A page from Ali George's journal explores limitations.

CONCLUSION

I want to close this chapter with this thought for your consideration:

Be mindful of collecting quotes that are inspirational but not instructive. I benefit more from substance. I need a direct assignment, something real to work with. Some inspirational phrases sound great but tell us very little. For example: "If you treat problems as possibilities, life will start to dance with you in the most amazing ways."

Hmmm. Perhaps inspiring, but what does it actually mean? And how do you turn this concept into practical application and use the idea in real time, here in your very real, very limited studio space?

One angle might be to analyze the sentence by writing about it, which allows you to pick it apart and figure out what it really means. Where do your thoughts go?

Writing led me to translate that line into this: If I treat problems as possibilities, I won't quit working just because I am discouraged. I'll keep going and I'll feel good about not stopping. I might actually have a breakthrough! Could come from working or could be serendipity. Either way, I'll be floating on air, pumped with ideas when I leave the studio at the end of the session. Then Life will feel good and amazing. And I'll feel like dancing.

We should all feel like dancing occasionally!

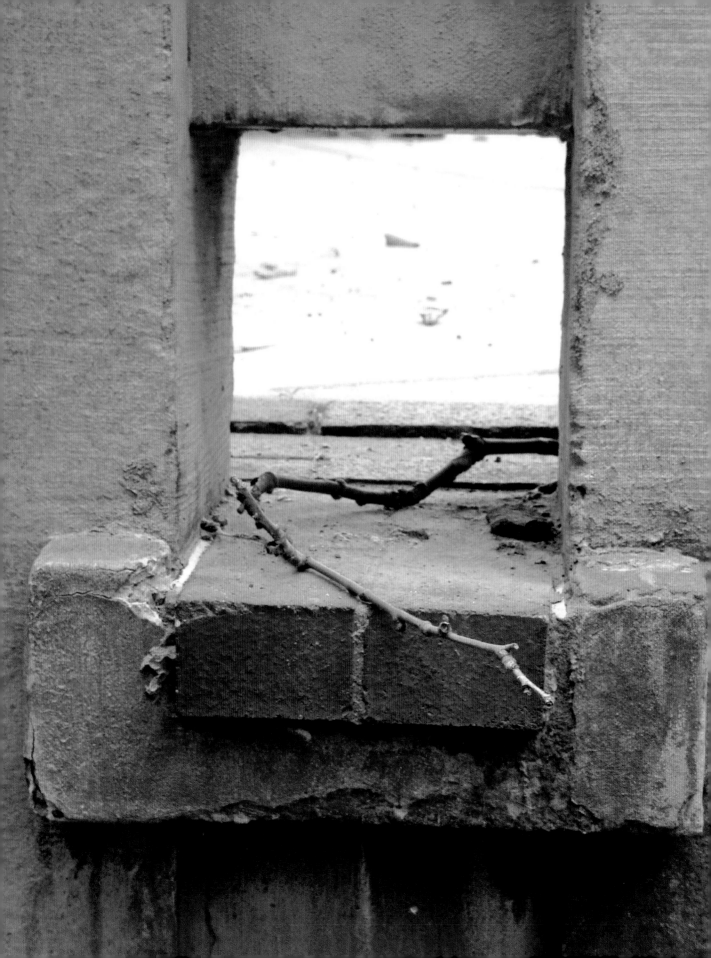

Learning to Make and Take Time

THE ART OF SLOWING DOWN

Acts of making establish their own rhythm and take their own time. A good vegetable stock can't be rushed without compromising flavor. I can't pick pecans from the tree in my yard on my own time. I have to wait for the nuts to fall, otherwise they won't be worth harvesting. Once I gather the nuts, I take them to a man who cracks pecans using a rumbling elderly machine, and I wait. When I get the box back, it takes several hours to separate nuts from broken shell. Time-consuming and even tedious, but the proof is in the delicious pies I make, gifting friends in December.

We can hurry studio time, but why should we want to? Does rushing ever make anything better? Is it satisfying to slap together a little this and that just to be able to say you've finished something?

Practice slowing down. Savor the materials in your hands. Offer undivided attention and time to them. Wait for the blossoming. Listen to what they'll do. Keep working. See what happens.

Constant, slow movement
teaches us to keep working
like a small creek that stays clear,
that doesn't stagnate, but finds a way
through numerous details, deliberately.

Deliberation is born of joy,
like a bird from an egg.
Birds don't resemble eggs!
Think how different the hatching out is.

A white-leathery snake egg, a sparrow's egg;
a quince seed, an apple seed:
very different things
look similar at one stage.

These leaves, our bodily personalities,
seem identical,
but the globe
of soul-fruit we make,
each is elaborately unique.

◈ Jalāl ud-Dīn Rūmi,
　("Deliberation" excerpt translated
　by Coleman Barks)

REALLY BIG OR REALLY OBSESSIVE?

***Study in Red and
Red Orange***
Catherine Kirsch, 2013
12" × 12" (30cm × 30cm)
Fiber reactive MX dye, Seta-
color fabric paint, embroidery
floss on linen

Have you ever thought about the wow factor of *making*? You know what I mean by the wow factor. It's what happens when you see work in a gallery or workshop, and your immediate, visceral reaction is *wow*. I've been trying to unravel the wow factor most of my life.

Lots of artwork is easy to like—pieces with gorgeous color and a few appealing visual elements. I knew an artist who spent his entire career composing functionally pleasing collages—either bold in the use of materials or delicate and almost wistful. His work sold well and I think were he still alive, he would say he had a good life and a satisfying career. But Henry's work never elicited a "Wow!" At least not for me. By the way, the disclaimer: Some of this is definitely personal preference.

In thinking about this, it occurred to me that Henry's pieces were always small, which led to wondering whether size plays a role in the wow factor. A lot of small pieces feel unresolved. What's going on with that? Do small pieces run the risk of being perceived as studies, rather than completed work, if resolution isn't handled deftly?

Test my theory by asking: Are there pieces of art that would be better if they were bigger? Does working bigger change the dynamic? I think the answer is sometimes yes. I've seen small works that would definitely be more compelling if they were bigger. From this realization came another: Viewers are impressed by big work. So one way to get the attention of galleries, juries and curators is to work big.

However, just because a work of art is big doesn't guarantee it is good. There are plenty of crummy big

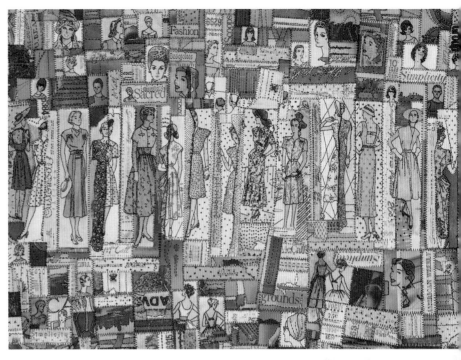

paintings. But, no doubt about it, size does get attention. And when size is linked to a larger-than-life theme, it really works. Subject matter may dictate scale. Scale can make or break subject matter.

Not long after my analysis of size, scale and their relationship to impact, I reviewed images as an exhibition juror. Midway through image selection, I had a new revelation. The work that blew me away wasn't huge stuff, although there were a few strong larger pieces among the submissions. What mesmerized me—and led to thinking *wow!* right and left—were small pieces such as the work of Mary Ruth Smith, which is almost always under 24" (61cm) and extremely compact.

What was this about? Her work: Strong? Check. Focused? Check. Felt complete? Check. Small? Definitely. Why were the pieces unforgettable? Obsession.

Works of art elicit a wow when our first response is one of the following:

How long did that take? Unfortunate, but true.

How did she do that? Keep them guessing.

Or simply, OMG. Wow!

Smith's pieces take hours to complete and involve thousands of hand stitches. Hers is not the only work in the category of obsessiveness. The American Visionary Art Museum in Baltimore is filled with obsessive artwork, from a 3-D diorama 12' (3.7m) long made with toothpicks, to a bra ball, created by rolling eighteen thousand bras into a bundle that would mow you down if it got out on the street and found a decent hill.

So those are two aspects of the wow factor. Work big or work obsessively, which might not be a problem for you. Maybe you're already entrenched in one strategy or the other; if so, please write to me and let me know how it's working for you.

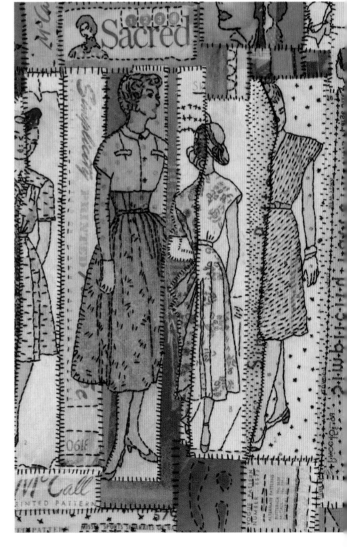

Pattern Recall
Mary Ruth Smith, 2015
27" × 38" (70cm × 97cm)
Laminated paper on silk organza, hand stitching

THE DEEPER TRUTH

Time passes. Thoughts ripen. While I'm convinced that working big or working obsessively builds an audience, consider this: Formula rarely works for long. Formulaically working bigger or trying to be obsessive (as if that's something you can cultivate) isn't really the answer. Your ideas won't necessarily go bigger. You may love clean and simple. Or small. It's not one-size-fits-all.

So dig down to a deeper truth. You can't hurry good work, and you must do whatever it requires of you. You won't know what that is—whether it is working bigger or adding obsessively more to a piece—unless you slow down and sit with it. Sitting with it may prove that neither large nor obsessive is a good fit for you.

The real lesson is learning not to whip something up just to be done with it. There's no race. Whether work will sell, win awards or make you famous doesn't have anything to do with the present moment of being engaged by work you love to do. And want to do well.

It's a paradox. If you give your work what it requires and don't question how long it will take, or whether you are capable of the tasks at hand, you will probably succeed. Making a piece big or being obsessive about the work in ways a viewer recognizes, are only two ways to create art that resonates. Putting heart into the work, never rushing and doing whatever needs to be done is the third way to create art that sings. To understand this, it helps to be quiet, turn inward and listen. You may find that two of the three qualities—big, obsessive or thoughtfully rendered—have alchemically commingled. Hence, the name of this chapter.

Building stamina involves engaging the Rebel Artist to protect and help make time for study, contemplation and exploration of materials and process. *Making* time has a rebellious side to it because sometimes *finding* time is a challenging battle.

But the other side of the equation is the need to take time. This is a gentle action, not rushing but rather slowing the pace. Taking time means breathing into process. As Rūmī wrote in the poem at the beginning of this lesson:

Creation unfolds like calm breakers.

Constant, slow movement teaches us to keep working

like a small creek that stays clear,

that doesn't stagnate, but finds a way

through numerous details, deliberately.

In this sphere we are completely removed from issues of scale or obsession. A piece may unfold quickly or slowly. Either is good. The gift of taking time is the opportunity to be lost in time or for time to stand still, even while studio hours surge forward. As mystic Kahlil Gibran wrote in *The Prophet*: "And is not time even as love is, undivided and spaceless?"

**Study in Red-Violet and
Red-Orange**
Catherine Kirsch, 2013
12" × 12" (30cm × 30cm)
Fiber reactive dye, linen, lamination,
hand stitching on paper

LEARNING TO MAKE AND TAKE TIME

MAKING TIME

Will you do it? Will you turn down one invitation this week to spend time in the studio instead? Will you forgo one errand in favor of spending time working on your art? Give up one day of strength training at the gym in order to strength train in the studio?

Bottom line: If you answer no to the above questions, it's OK. There is no right answer. There is only *your* answer. Accept your answer, whatever it is. Then let your studio practice revolve around that answer. It's as good a reason to be reading this book as any because a major Life goal—not book goal, not artist's goal—is to make peace with choices. Acknowledge your choices.

Make peace with yourself now.

But of course . . . we're makers, so forge ahead! Because you *can* do it all, or at least a lot, especially when your priorities are straightened out. You have acknowledged the time you are willing to invest in your studio practice. You're working on balancing everything. Good.

1 CONSIDER GOALS OR STRATEGIES

Eliminate internal conflict by knowing thyself: goals, time commitment, strategies for making.

2 PRIORITIZE

Identify what is needed to support your practice, whether it's a few hours a week or several hours every day. Accept this as who you are. Embrace it. It could change. But it's who you are now. Even if you don't have optimal amounts of time now, you have a goal to work toward, which is encouraging.

WHAT TO GATHER

◈ your day planner or calendar

◈ journal to record thoughts

TAKING TIME

Lessons in taking time do not roll out from a teacher, even when we pretend they do. The days of significant others (whoever they are) shaping your performance can wind down—beginning and ending with self-examination—until *you* are the boss of you. How will you gently and consistently encourage yourself to take time for gluing, stitching, ironing, painting, mending, researching—whatever is needed to maintain the connection between who you are and what you want to make?

Play these games to settle mind and engage hands. No exhibition. No goal. Just playing.

Try Obsessive on for size. Consider using:

» Your age: Find enough bits and pieces to add up in whatever way adds up for you. Permanent or impermanent, you decide.

» 100 anything. 100 black beans? 100 strips of paper? 100 shells from the shore? Do you have 100 of anything on hand, and if so, how can those become something bigger than 100? Glue, embed in plaster, string. Find 100 things, then decide how to combine them.

» Stitching. Can you stitch (or draw or collect or fill in the blank) an entire paper or cloth or wall? Start with a small piece of paper. Sew it to another one. Or sew leaves together. What else? What if?

» Have enough space to go big but haven't tried it? Or would working big really just be working bigger? It's relative and might depend on the weather. In any event, look at the average size of what you create, then triple it, for starters.

» Have you ever danced with a broom loaded with black paint? The marks are freeing. (You might need plastic on the floor or the driveway.)

These are stretching exercises. Do something you haven't thought about doing before in an open-ended way. Watch where your mind goes while you are playing. You may never glue 100 black beans to cardboard again, but where else can it take you? Take time to find out. Make time to explore all of this more than once. Increase your flexibility. Practice is good.

"Yo-Yo Mo-Mo," Carol O'Bagy's response to the challenge to use 100 of something on hand to create art. Her doll sculpture was created with a found doll and purchased silk yo-yos, glued and stitched.

ARTISTS RESPOND

Carol Wiebe's hand-painted journal

I took my sweet time putting free-form crochet edges on my quilted paper journal. To me, that gives the pages the look of deckled edges. I just happened to deckle them on all four sides (a little obsessive, perhaps).

I also started painting the first few pages. They are nowhere near complete, but I am observing as I play with the paint, waiting for direction to emerge. I did think about calling my art journal "Willing" and putting in some of the haiku I've been writing since that casual suggestion was made a lesson or two ago:

Trees know how to reach
I will reach out like they do
Touch the spacious sky.

❖ Carol Wiebe

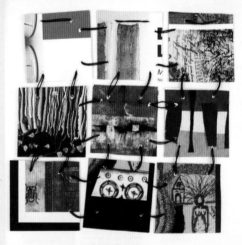

Joanne Weis's postcard chain assembled from hundreds of exhibition cards she'd collected

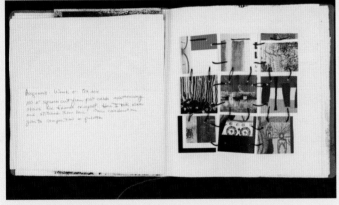

Joanne Weis auditioned her idea for a postcard chain in the pages of her journal.

Time is a valuable commodity. Time and money are a balancing act and usually mean a trade-off. For example, as a working mother I had to figure out how much income I could reduce to increase the time needed with my children. I can almost always tell you what time it is, though I don't wear a watch. At the same time, I value variety. If I am counting a bunch of things, I change the color or size of what I'm sorting, just to diversify.

With that, this exercise seemed monumental even though we had choices. I selected gathering 100 of anything and combining to make one thing bigger than the 100.

I collect postcards from art exhibitions. I collected a bunch of duplicates of postcards, cut them up into 100 squares, then stitched all 100 of them together in a long strip.

As I did this, I found the repetition relaxing and realized that I was enjoying the random combinations of color and shape that were emerging.

❖ Joanne Weis

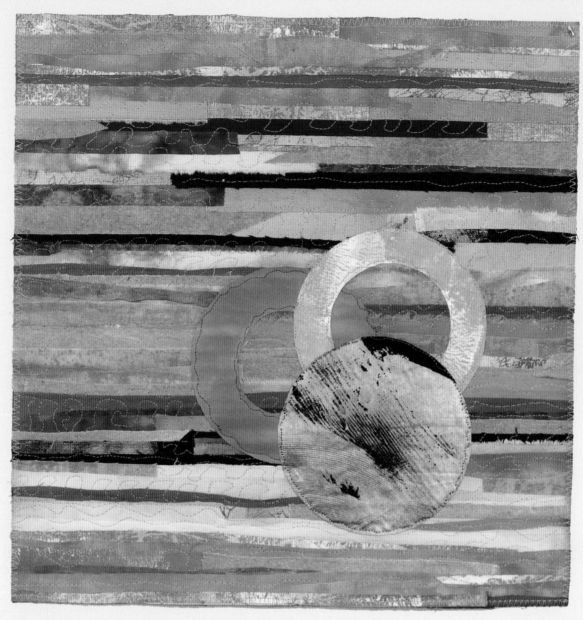

Sandy Kunkle worked with materials she already had on hand to create her stitched collage.

I began with a plastic box full of scraps, mostly small ones, backed with fusible adhesive. I began pulling out narrow strips. I work primarily in earth tones so there was no need to think color. I just began laying them on the paper and when I had a few rows, I ironed them down. I continued to work intuitively until I had used 100 strips. There was some obsession counting strips, but the real obsession came when I decided to stitch them all down!

What did I learn? Play really allowed me to move quickly into the zone and then I was lost in time. As a super planner and organizer, this exercise told me that working intuitively can be freeing. I have been having brief insights about working intuitively all winter, and it's exciting to have those insights building toward a practice. This little tiny voice is getting louder, telling me that I might find that elusive center deep inside me from where I have always sought to work.

❖ Sandy Kunkle

Martha Tabis collaged papers to make this comment on throwaway culture.

I found that working without a goal or an exhibition is relaxing, joyful, rewarding. Slowing down and letting work grow yields surprises, such as how a mishmash can become a unified piece, knowing when enough is enough and discovering solutions! For example, the newspaper "rind" on my watermelon and blackening one wine cork from my precious collection, then Photoshopping it!

Advertising and packaging art have always fascinated me, having a background in advertising. Raiding the kitchen for prepackaged paper reminded me what abundance we enjoy. I thought about making a statement about material goods, waste, throwaway society. Watermelon gum inspired the template.

❖ Martha Tabis

Irene Landau
Rice, beans, digital photography

100 Rice, meet 100 Black Beans. They group, they posture. They fight and, despite the barricades, the Black Beans vanquish the Rice completely.

I could see using "Rice and Beans" as a group activity. It would be very interesting!

❖ Irene Landau

Breaking News: My Rebel refuses to glue 100 beans, paint with a broom, triple the size of current work or stitch. Why? Time. Time. Time.

Time is the point for me. I will merge your permission to customize this assignment with my own and make creative time for something, but not for gluing 100 beans; I know I have permission "to make peace" with what I choose.

I set out to take time with a drawing of orchids, a task I loved but didn't finish. I tend to sketch and paint hastily, and that's what happened when I attempted to slow down my sketching. Drawing at a fast pace is an outlet for my anxiety. Scribbling, pushing value and color very fast, creates release, but there is less opportunity to allow

a sense of the small parts and gradual accretion. Think how patient nature is in its incremental building.

Here's something to be conscious of. Since I started this course, I stopped playing computer solitaire, cleaned out the worst part of the basement and things are much better now with my husband. (He gets some credit for that.) There are still more messes to clean, more personal growth and hopefully more conscious moments to discover. I'm still struggling with time and how to be deeply in my art, but it's shifting.

❖ Pippa Drew

Orchids with Pen and Ink Fill
Pippa Drew, 2014
12" × 8⅝" (30cm × 22cm)
Pilot pen on drawing paper

CONCLUSION

I've fallen off bicycles, scraped my face along the street and been in four car accidents, including one where the car landed upside down in the middle of the median in a driving rainstorm. The *good* voice I always heard in my head (eventually, not always right away) said, *Get up, dust yourself off, count your blessings, keep going.* Some might say that's an angel talking. Some might say that's just what humans are wired to do. Doesn't matter really, does it? The important part is the dusting off, paired with a healthy dose of renewed resolve. Keep showing up.

So if you don't have as much time to work on exercises as you like, or if you've hit a rough patch, don't beat yourself up. Guilt is wasted energy. Give yourself a break. Pick up where you left off. Keep showing up.

Remember that while habits can be changed in ten weeks, they don't change without effort on the part of the person desiring the change. When you're in it for the long haul, you falter and then show up, falter and then show up—endlessly—just like the waves on the sea, rolling in and out from shore at a steady, rhythmic pace that gradually wears down the coastline.

Verse 78 from the *Tao Te Ching*:

Nothing in the world
is as soft and yielding as water.
Yet for dissolving the hard and inflexible,
nothing can surpass it.

Be like water.

Étude # 40: Cultivating Patience
Jane Dunnewold, 2010
11" × 43" (28cm × 109cm)
Rice paper, sand, dyed silk

*Étude # 25: For Trumpet, Choir
and Elinor*
Jane Dunnewold, 2010
12" × 45" (30cm × 114cm)
Rice paper, vintage music, sand

CHAPTER 6

What Does Alignment Look Like to You?

DO WE EVER HAVE ALL THE ANSWERS?

As a teenager, I naively believed that as an adult *everything* would work out; everything would finally be revealed. I would have clarity and understanding. Fact is, it hasn't happened. Instead, I've learned that alignment—understanding why I am here, what I love to do and how I am going to pursue it—is definitely fluid. To act as if I had it all together and never doubted myself would be disingenuous. I have to keep recalculating. But I'm on it, because I know alignment is the route to satisfaction and joy.

And what is it to work with love?
It is to weave the cloth with threads drawn from your heart, even as if your beloved were to wear that cloth.
It is to build a house with affection, even as if your beloved were to dwell in that house
It is to charge all things you fashion with a breath of your own spirit,
And to know that all the blessed dead are standing about you and watching.

◆ Kahlil Gibran
from The Prophet

ALIGNMENT

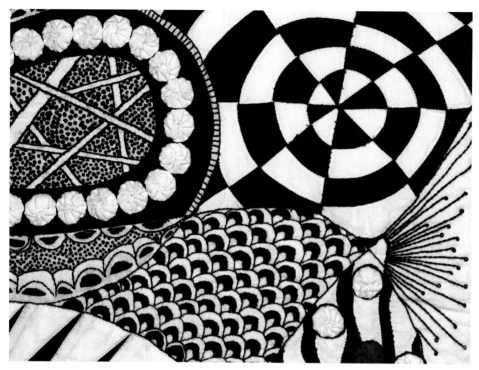

Zen (detail)
Beth Schnellenberger, 2012
24" × 30" × 1½" (61cm × 76cm ×4cm)
Hand-stitched French knots and
satin embroidery stitches, yo-yos,
bias strips, fused appliqué and
paper-pieced spikes

Life is short and studio time is finite. Ideally, time spent in the studio should be a balanced combination of what you're good at and what you like to do.

I characterize this as being in alignment. If more time is spent on tasks you don't enjoy than on those that bring delight, you're out of alignment somewhere.

Of course it takes practice to master technique, which can be tedious and not fun. Generating tools isn't always entertaining; it's work. Finishing a piece? Downright dull, but not getting it right could ruin even a masterpiece. So being in alignment doesn't mean you love the task at hand. It means you do it anyway, knowing it's a nonnegotiable part of making. It's a paradox. Time-consuming tasks—making tools, priming canvas, ironing fabric—eventually free you to play. When the prep is done, you can let the good times roll!

But how do you discern whether you're in alignment or not?

First, analyze your current skill set and evaluate it. Many of us have skills we're good at, but we don't want to use them any longer. My friend, Sue, admitted that while she is an expert piecer of quilts, she's through piecing. Sue recognized she was out of juice and, therefore, out of alignment. What about you? Are you still using techniques or materials just because you know how or are good at them? Has joy left the room?

Next, consider your wannabe skill set—abilities you wish you had or employ but not masterfully. Is practice needed? Are you struggling? Would you like to learn to do something new but are intimidated? It doesn't matter where you are in relation to where you want to be, but do be honest with yourself.

If a skill requires practice to be top-notch, make improvement a goal. Getting really good at a skill you value leads to confidence. And confidence leads to alignment.

There's another aspect of alignment worth noting, and that's the matter of personal style. This isn't about clothes or makeup. It's the vision you bring to your work, which is intrinsically related to what you love to do. Beth Schnellenberger loves to stitch by hand. She showed five pieces to our critique group and lamented the lack of connection between them. But on closer observation, the pieces exhibited three commonalities reflecting Beth's emerging style:

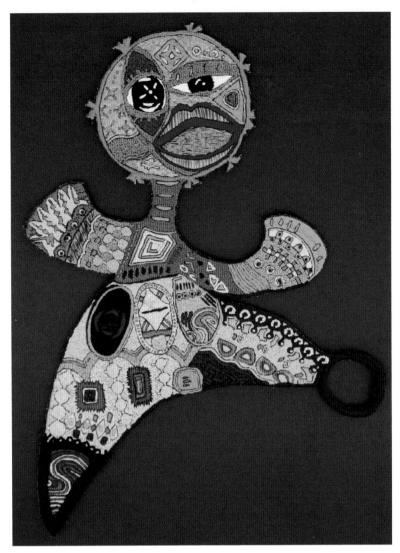

Metamorphosis I
Beth Schnellenberger, 2014
17" × 11" (43cm × 28cm)
Layered muslin over Eco-Felt. The muslin is entirely covered with dense hand embroidery.

If you always do what interests you, at least one person is pleased.

◈ Katherine Hepburn

» Strong graphic qualities, employing varied techniques, all filtered through her love of high-contrast, bold patterning.

» Color: The choice of fabric and thread reflected her love of vibrant pure color, black and white.

» Intricate hand stitching: She has the time, intention and ability to add hours of beautiful embroidery to her pieces and never regrets the time or the effort.

By analyzing personal style and acknowledging what she's good at, in addition to what she loves to do, Beth was able to see her Artist Self more clearly and set goals for the future. What Beth did is exactly what each of us can do in order to achieve alignment and create artwork that is distinctively our own.

STRATEGIES

Another question to consider: What would perfection look like if your work succeeded in achieving it? You may not really care about achieving perfection or think it can't be done or doesn't matter. But at least ask yourself the question. The answer might guide your quest for alignment, which is a natural component of perfection.

Now the reps of strength training come in because once you know what you're good at and also what you like to do, you can determine what is required to achieve your goals and chart a course of action.

The goal for this chapter is an inventory of your skill set. Decide what to keep, what to cast off and where to put energy in order to improve. It may not be quite as simple as it sounds, but taking time to lay out the map is valuable. Later, if you take a wrong turn, you'll have coordinates to find the way back to the path.

WHAT DO YOU LOVE AND WHAT ARE YOU GOOD AT?

CROSS-TRAINING EXERCISE

BEGIN WITH THE INVENTORY

By going through this exercise, you may discover a skill capable of transforming work you're making. Until you make an inventory, you may find you take for granted many skills that could be applied to making art, even if you've not used them in that capacity previously.

> ### WHAT TO GATHER
>
> ◈ favorite writing implement
>
> ◈ something to write on (journal or loose paper)

1 LIST YOUR SKILLS

Make a list of your skills. (See Joanne Weis's example on the opposite page.) Evaluate each one in terms of how good you are at it.

2 THINK ABOUT SKILLS YOU ENJOY USING

Next, look at your list. Rate each skill based on whether you enjoy it or not. Think of this as the "desert island test." If you were stranded on a desert island, which of the skills would you be relieved to have brought along? Which ones would make your heart sink because you're so bored with them?

3 DEVELOP SKILLS FURTHER

What do you wish you knew how to do but don't? What skills do you wish you could improve when you revisit your first list? The third part of the exercise is to write a list of skills you want or need to learn and then another list of skills that need strengthening. Be honest with yourself.

You may think you want to learn to blow glass, but is this a whim you are unlikely to pursue or one with real energy? Most of us waste a lot of time thinking and talking about what we want to do or might do, uh, that is . . . sometime later. Do you use this smoke-screen to keep from doing something real in present time? Don't delude yourself.

Writing is good strategy. Make a list of things you'd like to learn. Keep it to yourself. Read it every few months. You'll either find yourself inching closer to one of the skills on the list, in which case it's probably time to commit to learning it, or the idea will have lost its animation. If there was ever juice, it dried up. Cross that one off the list. A regular inventory is important. Don't let a bunch of stale "maybe someday" ideas occupy your head, where space is at a premium! Keep your energy, commitment and stamina reserves fluid and in real time.

ARTIST STRENGTH TRAINING
WEEK 6
WHAT DOES ALIGNMENT LOOK LIKE?
JOANNE WEIS

THINGS I ENJOY DOING AND DO WELL.	. . . DO SATISFACTORILY.	. . . NEED IMPROVEMENT.
IN MY DAILY LIVING:			
Writing			
Public speaking			
Relating well to people			
Taking notes at meetings			
Chairing meetings			
Reading novels			
IN MY ART:			
Making Thermofax and other screens			
Using screens to print			
Designing a piece with good proportion and composition			
Using soy wax as resist			
Using flour paste as resist			
Mixing colors			
Using colors			
Embroidery			
Bead embellishment			
Using text on textile			
Finishing work for presentation			
Stamping			
Rubbing			

Developing the above Alignment Inventory has been an awakening for me. First, I put down skills in general, including life skills. When I went back to code them for enjoyability, I recognized how blessed I am. Unless I enjoy something, I usually don't have to choose to do it. Life happens, of course, and there are some things that hit me in the face, but for the most part, I don't need to do anything I don't want to and frequently do exactly what I enjoy.

Joanne Weis charted her interests and abilities to decide where to spend her time.

PERFECTION

What does perfection look like? Close your eyes. Imagine yourself using skills you love and have mastered. Can you quantify what it would take in order to be completely satisfied and *in love* with something you made? How close are you to being there? Do you think it's possible? One of the most important parts of this exercise is to notice what you are thinking behind what you are writing. Our thoughts are related to our reality. If you don't believe you are capable of achieving perfection, this is a good time to ask yourself why? Because no matter how much someone else believes in you (and that includes me), perfection will never occur if you don't believe you can do it. Singer Jackson Browne wrote, "In the end there is one dance you'll do alone." Actually, there are several. And this is one of them.

So take a good look at your Artist Self and decide intentionally to love it, no matter where you think you are on the alignment continuum because nobody achieves perfection all the time, but everybody is capable of achieving perfection at least once. If you show up, work consistently, keep track of ideas and progress, you can be proud of yourself. I once read you have to do a lot of really bad work to get a few really good pieces from your efforts. That's probably right, no matter which direction your creative inclinations lead. But it doesn't hurt to know what perfection looks like. It will make it easier to recognize later, when you see it happening right before your eyes.

What if you've achieved perfection in the past, but now those skills no longer engage you, like my friend, the expert quilt piecer, who was through with piecing? This is a fortuitous, scary, vulnerable place to be. On one hand you know you were capable of perfection—or close to it. On the other hand, what the heck happens now?

There aren't easy answers. There are, however, a few questions. What do you want to do now? Is a new love beckoning you? Can you riff on what you used to do? Is it time to switch creative gears (and mediums) entirely? Some people would advise you to sit with this and think about it until you have an answer. I would suggest a proactive choice: writing. Use writing to free-associate, make lists, tell yourself a story. Writing speeds up thinking or at least records it. Later you can look again and push back against what you wrote. Or embrace it.

YOUR DISPASSIONATE VIEWER

Artists join critique groups, enter juried exhibitions and show new work to friends and family all the time. Most artists don't feel the creative circle is complete until somebody else validates their work. That's fine, but when was the last time you sat with your work—all by yourself—and determined its strengths and weaknesses? Consider making this a practice for every piece you finish, before you share it with anyone else.

Cultivating an inner dispassionate viewer is a paradox: Artists are usually passionate. That's the painful, gloriously personal side of making art. But cultivating an ability to analyze work impersonally is beneficial. Reviewing strengths and weaknesses doesn't shut working down. Distancing enhances your ability to believe that work can improve with time and practice, and it is the dispassionate armor that keeps someone else's opinions from piercing you.

It's another strength-training exercise. A therapist once told me most people can deal with anything as long as it's the truth. We flourish when our realities are validated because we're standing on solid ground.

CHECK IT OUT

Practice sitting with your work and studying it dispassionately. Review a completed piece on hand in the studio. Analyze a piece you really like, based on alignment, strengths, weaknesses and perfection. Write your comments down. Perfection not required. Acknowledging what really worked and what you would do differently if you had it to do again is enough. Then take a shot at a piece that disappointed you. The more you do this, the easier it gets.

There are no shortcuts to any place worth going.

◈ Beverly Sills

Pilgrim (detail)
Jane Dunnewold, 2005
85"× 34" (216cm × 86cm)
Paint, gold leaf on silk

Take jurying, for example. Jurors are human beings. If you think they don't have personal preference and biases that affect the show they choose, you're naïve. Recognizing this makes it so much easier to handle rejection. If jurors wrote comments on work that was rejected, you would be fine if the notes on your piece said, "Didn't like the color" or "Wasn't crazy about the subject matter." That's not about you, that's about someone's personal preference. OK, fair enough.

However, if the notes said, "Poorly constructed" or "Study color theory and try again," your feelings might get hurt because the truth hurts.

So why wait to hear the truth from someone else, in a setting you could have avoided? Toughen up. Sit with your own work. Figure out what's working and what isn't. It will lead you back to what you love and what you're good at. Alignment.

Judy Cook chose this collage to critique strengths, weaknesses and alignment.

This is a collage based on a photograph. The photo was pixilated in Photoshop, giving it the crosshatch appearance, printed and glued to the canvas, then hand-colored. I used a transfer process to transfer the words.

The text is a story of my mom's first perm for graduation during the Depression years, which was paid for with chickens and cabbages. The picture is of her with her sister in their graduation dresses.

STRENGTHS

I like the surrealism.

The text draws the viewer's attention into the picture and makes the viewer look closer.

I like the way the girls look like they are standing on the music.

There is a lot of movement in the large sunflower.

I think the color is balanced from blues to yellows. I like the spot of red in the cowboy boots.

WEAKNESSES

Parts of the composition look pasted together. It could flow better and be more cohesive.

Not sure about using the photograph; maybe redo the piece with a drawing?

The text is computer generated. No one likes their own handwriting, but in this case it would fit the composition and story.

After Judy analyzed the strengths and weaknesses of her first piece, she decided to re-create it, this time using dyed cloth and screen printing from drawings she did herself.

**Class of 1934: A
Graceannah Story**
Judy Cook, 2014
71" × 21" (180cm × 53cm)
Fabric, dye, textile paint, silkscreens
made from original drawings

ALIGNMENT

I would like to explore further combining text and images to tell stories.

If I were to do this again, I would probably change the sunflowers to cabbages. The story is about cabbages, so it would make more sense. I would use a smaller text. I did some stitching around the flower. I like that and more of it would add interesting texture.

❖ Judy Cook

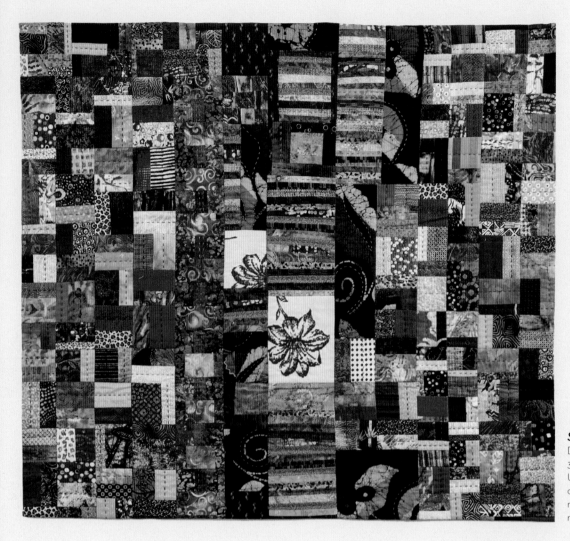

Springtime in My Garden
Deborah Franzini, 2015
30" × 40" (76cm × 102cm)
Upholstery fabrics and
commercial cottons,
machine-pieced, hand- and
machine-quilted

As weeks progress, it's harder for me to write thoughts on the current week's lesson separate from the whole. I am so aware that there is a big shift occurring in both the way I work and, now, the way I can assess my satisfaction with what I've done.

I made a piece many years ago responding to the suicide of a friend. It was very clear as I made it: This was the one way I could grasp some of what I was feeling. It has been in my studio since it was made.

Several weeks ago I chose to cut it into sections. It was like taking an artist's leap of faith—that it would come together in a new form instead of ending up in the trash.

I know for myself that the new arrangement is not quite complete. A part of me is pissed that it's "not done" (I took the damn leap of faith, didn't I?), and another part is intrigued by this idea of letting a piece take its time. I'm realizing that there is a sense of receptivity to an answer as I ask, what could be next? I began using writing to help maintain ideas that come up. Finally I'm beginning to see the value of all this writing!

❖ Deborah Franzini

At the End of All Things
Gwen Hendrix, 2014
24" × 30" (61cm × 76cm)
Dye, paint, tea towel on canvas

*Gwen Hendrix started with
a dyed tea towel and turned
it into a complex painting by
responding to color and form.*

Like the crow with a shiny object, I have been drawn to many art disciplines over the years. If a particular craft or medium piqued my interest, I would acquire enough knowledge to do it successfully. Thus, my skill set is broad and varied.

I agree that striving for perfection means getting really good at a skill set you value. Mastery of tools and techniques has been my regular practice throughout my art journey.

That said, my view of perfection agrees with this quote from Michael J. Fox: "I am careful not to confuse excellence with perfection. Excellence, I can reach for; perfection is God's business."

I have experienced this firsthand. As I was painting botanical illustrations in my teacher's studio, it occurred to me that I can't create perfectly that which has already been created by Nature. This was debilitating—so much so, I changed my process to mixed-media collage, which led to painting abstracts.

During this transitional phase, someone in a workshop said, "Perfectionism is the tool of the oppressor." Suddenly, the tightness that came with the perfecting of botanical paintings began to relax; imperfections in the work became happy accidents and things to expand upon; the process became fun.

For me, the pursuit of perfection as it relates to my work is limiting, boring and debilitating; a relentless pursuit that is not attainable. Therefore, for me, the greatest perfection is imperfection.

❖ Gwen Hendrix

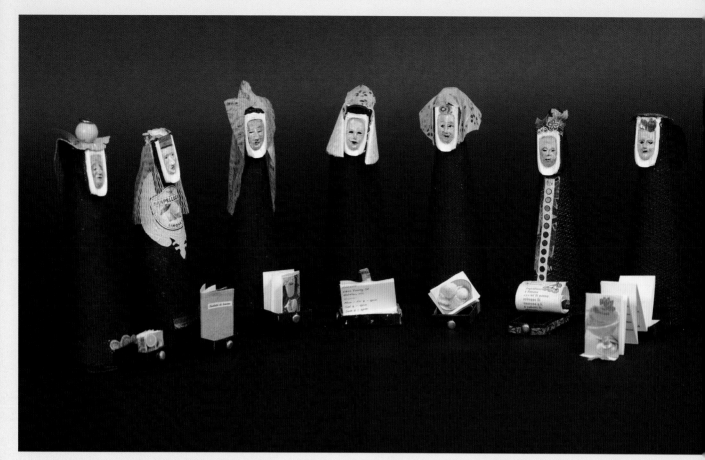

The Sisters of the Order of Saint Sorbetto
Kathryn Belzer, 2013
Seven figures, each approximately 7" × 3" (18cm × 7cm)
Raper thread cone base with matchbox drawers containing recipes;
various papers, paints and found objects

My Sorbet Sisters figures are the object of my review. This week was hard. I couldn't list skills. Every time I tried, there was a mocking voice derisively snorting that most people have more skill than I do in every area. Or the skill was too irrelevant to bother developing. Finally I confessed my struggle to my husband. He asked how much I'd accomplished that day alone. My telling was evidence against the mocking voice's assertion. With that

crap out of the way, I proceeded to Part Two.

I loved making these figures. The basic materials were bound for recycle at best and there was no commission or expectation from anyone. My story for them amused me. They are a sisterhood of shared purpose—complex and simple simultaneously.

They are rough. This can be strong or weak. Uniform roughness feels

satisfying. The size (a thread cone base with a matchbox drawer) works.

The recipes and Mother Superior's map to the sorbet store are weak in execution. I like the idea, but something isn't resolved. Maybe something about the collection of drawer contents. The paper is too crude or fussy. Somehow not just right.

This work isn't perfect. I haven't mastered technique or materials. The

paper clay faces were hard to keep neat, the gap between the cone and the spout hard to bridge. The work wasn't perfect. But it was perfectly suited to what I should be doing and can do better.

❖ Kathryn Belzer

CONCLUSION

Alignment takes time. But the slow unfolding continues—ebbing, flowing, questioning, experiencing flashes of insight. Find your own rhythm. Seek your own alignment. For each of us it will be a little different.

Making Work Distinctively Your Own

ONLY YOU CAN MAKE DISTINCTIVE WORK

I once read that beloved painter Vincent van Gogh was clumsy and inept, which would never have occurred to me. The author cited Vincent as an example of difficulties a gallery faces when a painter's brushstrokes vary from painting to painting. Really?

Van Gogh sold one painting in his lifetime. Methodical brushstrokes probably wouldn't have changed his sales portfolio much. It's doubtful, with his reputation, that he would have been inclined to play by those rules anyway. What we do know is that Van Gogh paintings are distinctive. We recognize his work as soon as we see it.

In this chapter we consider the issue of distinctiveness, where it comes from and how to cultivate it, because you're the only one who can make your work distinctive. No one else can be in charge.

FOCUS, ALIGNMENT AND GOALS

WHAT'S SO SPECIAL ABOUT BEING DISTINCTIVE?

What are we seeking as artists, if not ways to marry meaningful work to enjoyable work? Too often, we make pieces without personal significance and, unfortunately, not distinctive at all.

Being distinctive isn't easy. One class rejected the word *unique* as a cliché, but go ahead, try it on for size by asking what is unique about your particular take on a subject or process.

The Musée d'Orsay in Paris exhibited a show of early Impressionist paintings: an identical street scene interpreted by a dozen artists, each of whom experimented with this new painting style, Impressionism. Painters who really got Impressionism painted wonderful paintings. The ones who sort of liked the idea or were friends with Monet at the time? Not so hot. Their paintings looked forced; it wasn't a good fit for everyone.

Loads of textile artists do shibori dyeing or print dye with a silkscreen. There are thousands of watercolor artists, oil painters and potters in the world. Technique itself isn't distinctive. It's what the artist does with it that makes the process "art."

And what about artists who got there first? Monet was the master Impressionist. Nancy Crow perfected improvisational piecing. Jan Myers-Newberry uses shibori masterfully in her quilts. Trying to better a master is not for the fainthearted. The point is, what are you going to do to make a process distinctively your own?

WHAT MATTERS TO YOU?

We're building on everything we've talked about so far. First? Get comfortable with writing. Next? Engage the Rebel Artist to protect studio time. Limit the power of the Committee. Choose to use what's on hand so precious time isn't wasted running to the store. Make time for what you want to do, and take time to do it well. You feel pretty good because you recognize what alignment means as a personal attribute—what you love to do, what you're good at doing and what you need to do to improve.

Now consider exploring content by writing about what matters to you. It's important to point out here that what matters to you is what matters to *you*. It doesn't have to be world peace or gun control, poverty or religion, unless that's where your passion is. It can be flowers or beauty or color, form and line. Passion is not predictable. It's personal.

LIMIT YOUR FOCUS

Artists need experimentation and playtime. That's how a distinctive style coalesces. It takes time to distill neutral process into unique visual voice. Choosing to focus attention and energy deliberately—while limiting techniques or materials—speeds up the process. Focusing is good. So why are we intimidated by it?

Maybe feeling intimidated is related to an underlying fear that concentrating efforts in one place will result in leaving other opportunities behind, that somehow the choice is forever. But focusing on one area doesn't preclude ever being interested in others. It just means that for some length of time you've chosen intentionally to work within limits.

ALIGN PREFERENCES, SKILL SETS AND GOALS

There's a lot of bad art in the world. There are bad paintings and bad art quilts. Having said this, it's still true the bad work was worth doing because the bottom line is the value of process. What you learn from engaging with materials. How making defines, refines and reshapes the core of your soul. Don Henley nailed it when he wrote, "But you don't see hearses with luggage racks."

You may never achieve anything on the order of a Nancy Crow quilt or a Paul Gauguin painting. We're not all visionaries. But you have a right to create distinctive, satisfying work. This is a worthy goal. You'll be more likely to succeed if you align your preferences, skill sets and goals with what you care about. Because it's what you care about that makes work distinctive.

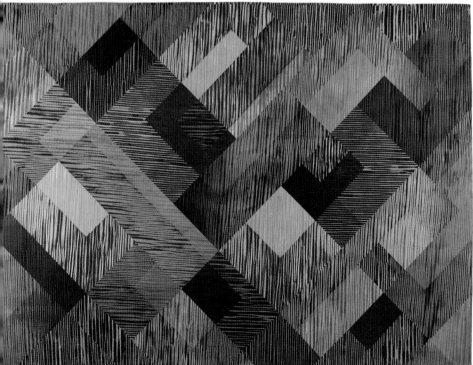

Tilt-A-Whirl
Jan Myers-Newberry, 2012
63" × 89" (160cm × 226cm)
Pole-wrapped with string,
condensed; underpainting;
discharge on cotton

Mother Board
Jan Myers-Newberry, 2013
54" × 76" (137cm × 193cm)
Underpainting, clamp-resist
patterning on cotton

THE FOURTH, FIFTH AND SIXTH CHAKRAS

Spiritual theorist Caroline Myss wrote about how ideas manifest in her book, *Sacred Contracts*. She used chakras, the energy centers in our bodies, to describe symbolically what happens when artists get new ideas.

The fourth, fifth and sixth chakras secure commitment to new creative ideas. They are referred to as the Heart, Throat and Third-Eye chakras. The Third-Eye chakra is considered the seat of wisdom in the body. Think of it as being connected to the grand universal ether, where it retrieves ideas for your consideration.

Once an idea lodges in your head, it floats there. You think about it. Analyze. Easy to do? Hard to do? Worth it? Thinking!

Now imagine the idea drifting down through your body, where it lodges in your heart. A new analysis begins. Would you enjoy the idea? Love it? Does your heart feel it's worth attempting? The Heart chakra either embraces the idea or not. If there isn't enough literal heart energy surrounding the idea, it will probably dissolve and never achieve fruition. We all know what that feels like!

If the Heart chakra embraces the idea (think of it as a quickening pulse), the energy between the heart and the mind is palpable. You know that feeling of excitement, too, when you can't wait to get started and literally see what the idea will look like when it manifests.

Once the heart and the mind are excitedly riffing on the idea, the Throat chakra engages. You speak your idea into the Universe. Speaking (fifth chakra) is commitment. You can think about an idea and love it, but the idea probably won't be realized unless you talk about it, usually by describing it to someone you know. Once you begin talking, you are figuring, planning, devising, and these are solid steps to seeing the idea manifest as a reality.

Third-Eye Chakra. Illustration by K Wayne Harms

Throat Chakra. Illustration by K Wayne Harms

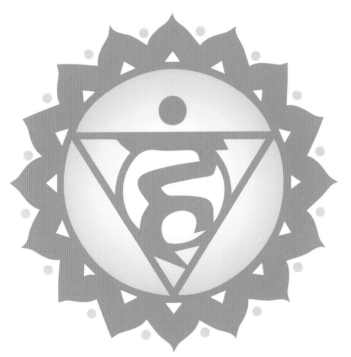

*Heart Chakra. Illustration by
K Wayne Harms*

Now consider a downside to what I'm describing: speaking too soon. Speaking before an idea gains the support of both the head and the heart can drain energy. You've talked it to death; the energy is gone. We all know people who talk, talk, talk and never do anything. They consistently drain ideas and speed them to certain creative death by talking when they should just be still.

It's a good idea to keep ideas to yourself at this early stage, which is why writing comes in handy, once again. Writing harnesses ideas within your reach, where they can continue to solidify, but protects them from the scrutiny of others too early in your process.

So don't rush to share ideas with the world. Ponder them until your heart and head are clamoring in unison. When the song is eventually sung, it will be solid and ready. Heart, mind and voice will be aligned, then you can decide what to do next.

MINING CONTENT

CROSS-TRAINING EXERCISE

Satisfying work may begin with content or may begin with processes you love. In the latter case, meaning arises as work unfolds. Either way is satisfying. Any artist can start from either place, based on intent and vision.

WHAT TO GATHER

◈ favorite writing implement

◈ something to write on (journal or loose paper)

WHAT EXCITES YOU

When a short list of topics excites you, a place to begin is never lacking. Here's how to get started:

1 THINK

What do you care about? You can think about it on your own or share ideas with a friend. Raise awareness by tuning in to the world. Visuals, radio, books—all provide clues.

2 WRITE

Try free association. Write "What do I care about?" at the top of a page and get going. Stop when you run out of thoughts. Review. What do you see? Another angle? Write an essay (yes, it can be a shitty first draft) describing what most brings you joy, saddens you, frightens you or touches a place inside that says, "I must do something."

3 PRIORITIZE

Your list may have thirty topics or four, no matter. The question to ask: Where will you start? Eventually you may be able to work on several series at once. But most of us do better focusing on one idea at a time. Prioritize topics and choose the top three. Now choose the topic to launch first. You may feel nervous about how you'll pull this off. But do you feel a little excited about this idea? Hurray!

Ladders
Jan Myers-Newberry, 2012
39" × 65½" (99cm × 166cm)
Underpainting, clamp-resist patterning on cotton

The next steps work in tandem with the last three. By the way, the best thing about this approach is that it isn't to get you working on a single piece. You are working on tools and subject matter, the foundation of a series. There's no way to know how far this topic will lead or when it will end. Degas painted hundreds of paintings of ballerinas. Chuck Close has used a distinctive and magnificent version of Pointillism (in varying permutations) his entire career. Don't get too far ahead of yourself!

Kerri Boase-Jelinek pursued with a passion, printing with objects from the natural world.

REFINING YOUR LIKES

Now that you've made lists and other bits of writing about what excites you, continue narrowing down how you might use this information.

1 FREE ASSOCIATION

Write a subject at the top of a page, set the timer and write whatever comes to mind as a list. Don't edit or judge. This list usually identifies elements that are already visual, which can be used as design elements in a series, if you intend to work with figurative imagery.

2 CULLING

Write down visual elements you noted as a new list. This is the beginning of gathering elements to tell the visual story. Organize elements to see how they look together. You may also notice what's missing or—more exciting—your mind may begin riffing immediately on where else this could go. What additional elements spring to mind?

3 SKILL ASSESSMENT

Now approach the project from the angle of required materials and tools. Scope creating the series by thinking about what you love to do plus what you're good at. How will it shape the tools needed to make the series a reality?

4 SYMBOLIC COLOR

At some point think about how color fits in. Some colors will be appropriate for your topic and some will not. Give thought to this early, in order to be intentional about the choices you make. Identifying colors now guides the choice of mediums you have on hand prior to launching.

Joanne Weis's writing for Mining Content

CONTINUING THE WORK

The process is cumulative. Once an idea is embraced, the free association provides visual elements and may also spur thinking in another direction! Ping! Ping! Ping!

Sorting elements to select those that best tell the story is followed by determining materials and tools. Don't forget to think about elements from a stylistic point of view: If the elements hang together stylistically, nothing gets in the way of the story. Be rigorous with this evaluation. One visually discordant element can throw everything off. There are occasions when this may be a deliberate act on your part. Just make sure it's intentional.

Fleshing out an idea by following the practice I've described automatically introduces the other elusive quality we've discussed: focus.

Working from content, even if the content is a set of nonspecific elements, a desire to explore form or color relationships (as opposed to content with a story line) is so

much easier than opening the toolbox of everything you know how to do and thinking *OK, what now?*

Settling on an idea first, followed by deciding where to go with it, focuses the project. Will you wander from the path? Possibly. Quite likely, as a matter of fact. Making is not static! Romping up and down the path should be encouraged and expected. But charting a basic map at the start means it's there: a source of ongoing navigation. If a detour doesn't work out, you can still return to the starting point to recalculate.

Making is a living, breathing relationship between you, the Artist Self and your idea. Staying the path you've chosen around every corner, no matter what the twists and turns, is the route to the distinctive work you will lovingly call your own.

The Punch Line
Gay Kemmis, 2012
30" × 55" (76cm × 140cm)
Felt, rayon, dye, fusing, stitching
on felt

**Rain Dance (the Hidden
Book Series)**
Betsy Miraglia, 2006
25" × 25" (64cm × 64cm)
Collagraph collage printed on
handmade paper

 # ARTISTS RESPOND

Buffalo Run (the Hidden Book Series)
Betsy Miraglia, 2006
25" × 25" (64cm × 64cm)
Collagraph collage printed on handmade paper

*F*ocus is my key word right now!

I often work in series with a similar theme throughout. My *Hidden Book Series* is an example. Here, the key word is *hidden*. I write in a journal, which is for my eyes only. By including the cover of a locked book, somewhat hidden, in each of the series' pieces, I conceal what is written within. The overall imagery creates curiosity in the viewers, hopefully holding their attention, while they explore the meaning in the pieces. Playing with the word *hidden* allows me to have fun, while I discover interesting ways to disguise the hidden book that tells my story, somewhere within the artwork.

❖ Betsy Miraglia

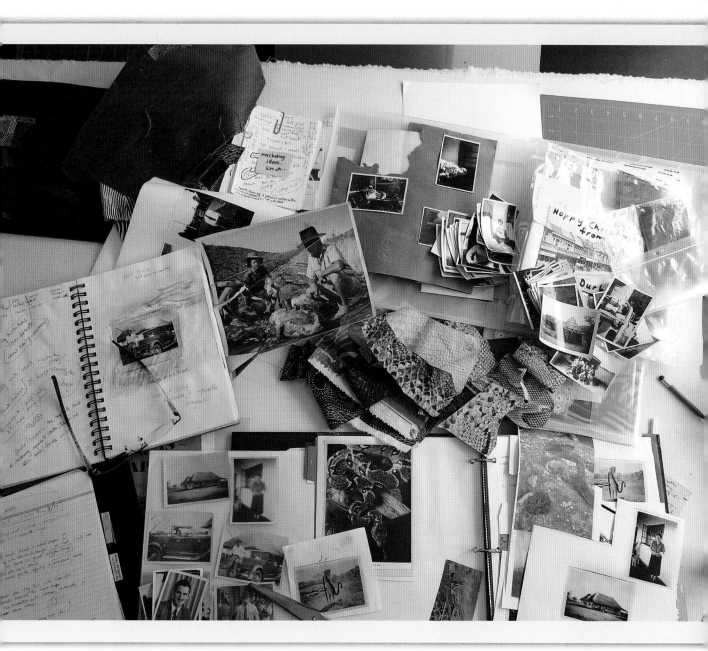

I'm only through Part One of the exercise, and my studio is a lovely rumple of old photos, clippings, notes, sketches and scraps.

Jane pointed out that when we have so many directions to go in, one can get frozen and not choose anything; we're scattered before we start. This verbalized a key stumbling block for me. I thought it was a personal failing. Seeing it stated in the essay made me realize it's a common obstacle. I'm grateful to see how to move through this: writing, being intentional about direction, setting some limits. This is gold for me.

Please note I'm returning to artwork after quite a long hiatus, so I wasn't sure what I'd find in my list of things I care about. Hmmm, I'm interested in the same things I was fifteen years ago! That's comforting. Someone once said, "All artists tell the same story over and over." I feel that's true in many ways, but I know what "my story" is. There is still more to say. I'm picking up dropped threads.

❖ Valerie Hearder

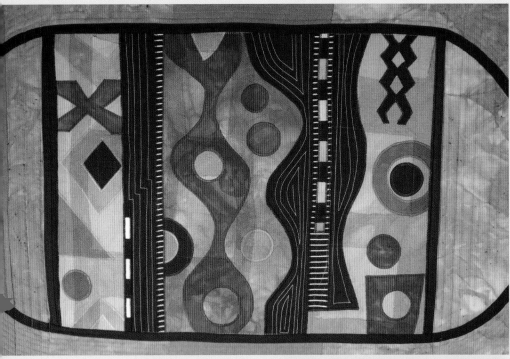

Mary cropped several images from the original, using Adobe Photoshop. This view is a crop of the bottom right of the piece.

In order to explore the potential for cropping an image and using the crop to generate additional work, Mary Elmusa started with her piece entitled, Encapsulated.

This view is made from the middle of the original artwork.

A long-ago beau resurfaced in December. This relationship spans several states and decades, with absences for years at a time. Only fifteen years ago, I discovered he's jolly-good company in a fabric store, full of enthusiasm and insightful observations. Two days ago, I called him and before I knew it, I was talking about my current project—the inspiration, the photographs, the ideas, the textures, the colors, the cost, the shifting ideas, the problems to be resolved. He was right with me on every bit of it. Then I remembered this week's lesson. I swear, the more I talked, the more I could see the project getting smaller and smaller, so I stopped myself and explained why.

It's very tempting to share art ideas with someone who understands the creative process. Today, I took the time to write all the things I started to share with him . . . and then some.

(By the way, when I'm feeling full of words and can't type fast enough, I pick up my cell phone and dictate an e-mail to myself. It's the easiest way I know to get out that miserable first draft—kind of fun, actually.)

❖ Mindy Fitterman

After Mary cropped the various sections, like this image from the bottom right of the piece, she also played with value by converting the image to a black-and-white version. These are great ideas for anyone who would like to explore abstraction as a jumping-off place for a series.

The process of mining content really made me think about keeping ideas incubating rather than discussing them at early stages. I believe in this policy and have witnessed how the power of ideas can wither away if discussed prematurely. This also goes back to the lesson on patience and taking time, all the time one needs, for ideas and for work to emerge to one's highest standards.

I developed a big picture goal this week (or it came to me, I should say), which could direct my future work but which I will refrain from discussing. I will say it's one that would help answer the question "Why am I making art?" with a bit more certainty. I feel it's worthy of my time. I feel good about the possibilities it may bring.

What I see as methods to reach this goal will take a *lot* of time. I feel my impatience rearing up!

❖ Mary Elmusa

Kerri Boase-Jelinek found a common aesthetic in fabrics she'd created over the past year.

Reading this assignment, I identified a few statements that really got me thinking Techniques in themselves aren't distinctive (everyone can do shibori); focusing involves working intentionally within limits for a period of time; focusing can assist with developing personal style.

I needed to stay at my mother's place last week. I took along fabric I'd made in the last twelve months. I laid it all out. Seeing it together revealed something I hadn't seen previously. I know there are lots of people doing what I'm doing, using plant dyes and earth pigments, but I've begun to move beyond what I've learned from others. In reviewing the fabrics, I could see where I started and where I was heading. There was an aesthetic that linked the work together. Mum and I talked until after midnight. It was a pivotal few hours. I went to bed with a mixture of being very tired, exhilarated and very determined.

Sticks and Bones
Jan Myers-Newberry, 2013
48½" × 68" (123cm × 68cm)
Cotton fabric rolled with various
wood strips, tied into bundles, some
underpainting

I'm feeling more grounded, quieter. Maybe my interests are still a bit too broad, but I believe I can enrich my practice by going deeper, not broader.

❖ Kerri Boase-Jelinek

CONCLUSION

There's no way to know how far a topic will lead or when it will end. Tibetan monks paint hundreds of energy circles. Mary Cassatt painted hundreds of babies. When ideas harness energy, artists never tire of working with them. Make time to discover the source of your distinctive energy, and go for it.

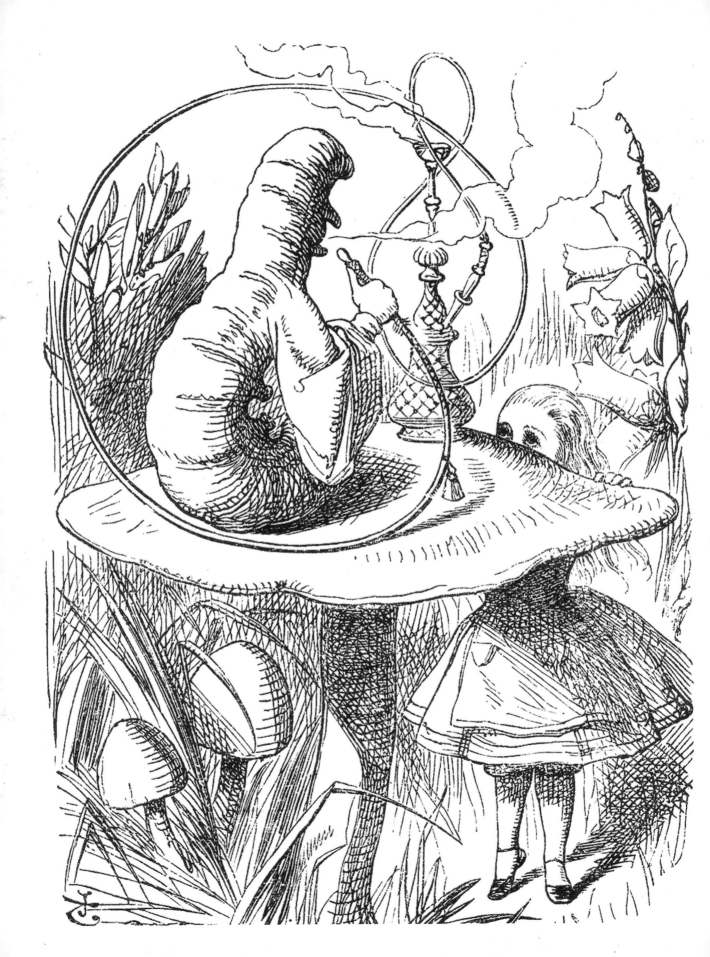

Each of Us Is Fascinating,
PART I

THE WHO, WHAT, WHEN, WHY AND HOW

I've never been to a party where someone asked outright, "Who are you?", which would cut to the chase but is obviously considered a rude opening. Blame it on the Caterpillar for setting a poor example!

In any event, there are plenty of things people ask each other to figure out the answer to that question. A friend of mine confided she sometimes thinks she's playing an unofficial game of Twenty Questions, and it's off-putting, so she doesn't go to parties anymore. We talked and decided it's because she's transitioning. Life is shifting. She doesn't know who she is any more than Alice did when quizzed by the Caterpillar, so she's uncomfortable with being put on the spot. Understandable.

And avoidable if you intentionally think about who you are because *you* are fascinating. She is fascinating. We all are! In this chapter we'll discover why by exploring who, what, when, why and how.

The Caterpillar and Alice looked at each other for some time in silence: at last the Caterpillar took the hookah out of its mouth, and addressed her in a languid, sleepy voice. 'Who are you?' said the Caterpillar.

This was not an encouraging opening for a conversation. Alice replied, rather shyly, 'I—I hardly know, sir, just at present—at least I know who I was when I got up this morning, but I think I must have been changed several times since then.'

◈ Lewis Carroll
 excerpted from Chapter 5
 Alice's Adventures in Wonderland

Alice's Adventures in Wonderland
Illustration by John Tenniel

EACH OF US IS FASCINATING

Here's a story about the time Garrison Keillor, author and host of a popular National Public Radio show called *Prairie Home Companion*, came to a party at my house. He was in town to kick off a new symphony season. My S.O. (significant other) at the time was a musician, so we knew all the symphony players. Garrison accepted a last-minute invite to the impromptu party as did most of the eighty symphony members. I started shopping and cooking on Friday morning. The party was at 10 P.M. that night, after the concert. Typical of who I was then, I planned a hugely ambitious menu for a day short on time.

The turnout was gratifying. The buffet table spectacular, if I do say so myself. Garrison produced a bottle of Minnesota red wine. I popped the cork and poured samples. The kitchen was jammed with people. I raised a glass to toast our guest as my seven-year-old daughter barreled around the end of the table. She threw her arms around my waist and red wine surged into the air. I was wearing baby blue silk.

Quick change of clothes and back to the kitchen where Philip Brunelle, Director of Vocal Essence, stood at the table, assembling a plate. He and S.O. were discussing Bach. I slid into the conversation by offering a napkin. Brunelle inquired after my father, having heard he was a big fan of Garrison's show. I nodded and enthusiastically gestured into the air. Brunelle's wine glass? A direct hit. Red wine splashed onto the cuff of his neatly pleated tuxedo shirt. S.O. grabbed Brunelle's arm in a panic and steered him toward the bathroom.

I fussed over the hors d'oeuvres, totally freaking over how the evening was going so far. I looked up and Garrison stood in the doorway, smiling expansively. "This is a great party," he said. "Why don't you come sit down and talk to us?" I nodded, poured a glass of wine and followed him into the dining room, where there was a chair saved for me right next to his.

"So," he said, "I understand you're an artist. What do you do?" The others at the table stopped chatting and looked at me expectantly.

"Oh," I said, "not that much, really . . . a little sewing, a little collage" My sentence hung in the air and he looked at me quizzically. I tried again. "Uh"

Before another word escaped my mouth, the harpist leapt in, regaling everyone with a hilarious story about trying to jam her harp into a Jeep. People roared with laughter. I pushed away from the table and slunk back to the kitchen to the safety of refreshing the veggie platter.

My party was a big success. At 4 A.M. S.O. stood between Garrison and me for a photograph. The orchestra PR person, who'd hung around to escort our famous guests back to the hotel, took a picture. Hugs and thanks were exchanged all around. In the kitchen, our dear friend, John the architect, was already loading the dishwasher. At such a remarkably late hour it was grounding to dry wine glasses and return them neatly to the cupboard. I was exhausted.

The PR person called me on Saturday morning. During the drive to the hotel, she'd asked Garrison whether he enjoyed himself. "I certainly did," he replied. "But that poor woman was a wreck."

We all know people who have absolutely no problem telling us how interesting they are. We've all cringed or rankled during the telling. If you grew up in a traditional family, you got the humility lesson early—the one that encourages you to lay low; don't make too big a deal of yourself. One time I wrote my name on a small notepad in a gas station and my father angrily wadded it up with the admonishment, "Fools' names, like fools' faces, always show in public places." Needless to say, I felt very foolish indeed. I was only nine. Don't think the gas station experience didn't come flooding back as I stood alone in my kitchen during that symphony party with Garrison Keillor.

Fast-forward to adult lessons in spirit, culture, energy and expectation, where I encountered the fresh idea that no one wins if we downplay our talents. They are meant to be used. Each combination is distinctive and fascinating. We are fascinating people capable of touching others' lives in powerful and life-changing ways. But how to maximize

From left: Conductor of the St. Paul Chamber Orchestra, Philip Brunelle, with Jane Dunnewold, John Carroll and Garrison Keillor

the potential? How to strike a balance between inflated ego and healthy self-esteem? How to proudly claim the Artist Self?

Begin by embracing the reality that when you get right down to it, everyone is fascinating. When the playing field is leveled it's no longer valid to believe we're better or worse than anyone else. There's no judgment. We're all fascinating in different, distinctive ways. Accept this. Then it's easier to state what we're good at or what we have to offer, without sounding braggy. The conversation becomes a discourse on what we bring to the table. The qualities we have to share. How best to serve: humbly, graciously. That's the key to self-esteem, defined

as having respect for yourself and expecting respect from others just as you extend respect to them. (My paraphrasing.) It's a mutual admiration society of the highest order.

And how about this? Accepting that everyone is fascinating means you must accept that you are fascinating. There isn't another option.

So how to decode your distinctive life experience? Employ the five standard questions used by journalists to write any comprehensive story:

Who? What? When? Why? and How?

Here's a visual. Picture an elaborate length of fabric with a multicolored woven pattern made up of textured threads. The overall effect is intriguingly complex. Every thread contributes to the pattern. But even better, pull out several threads to unravel the cloth slightly, and you'll discover the threads are different weights and textures. Some shiny, some matte, each interesting all by itself. The fabric is a perfect example of microcosm and macrocosm. The threads are distinctive up close; the woven cloth is distinctive from a distance. You are the cloth. Each thread of your experience contributes something. Together, the threads weave the fascinating whole cloth story that is yours.

You could begin today to write the story of your life from the earliest memory you recall, up to the present moment. Perhaps the writing would go easily enough. But formative moments and events have a tendency to get buried in the giant pile of Life experienced by anyone older than seven. The forest is too close to see the trees. Putting a few parameters around the telling speeds up both the process and the clarity arising from it.

As your guide, I propose a strategy that has worked for me, and I've seen it work for others. Begin with directed writing and get the shitty first draft down on paper. Then edit and as you do, ask the five questions (who, what, when, why and how). The goal is to discern life experiences that have shaped your Artist Self by following the thread linking earliest experience to where you are right now. Writing identifies each station on the path that has led to claiming and strengthening your Artist Self. Next, practice telling it so if anybody asks, you've got your story down, and you're good to go. With clarity, humility and humor.

Joanne Weis began to capture her story using a time line.

When I see Garrison Keillor again, and he inquires as to whether I am an artist, I want to answer quickly, before the harpist interrupts me, with a clear and buoyant "Yes! Yes, buddy. I *am* an artist."

KNOW THYSELF

Many artists decide they want to be represented by a gallery. There are definitely advantages to this, and it's often high on an artist's list of goals. A good gallery invests in its artists, not only by advertising and selling work, but also by acting as advisor, nurturing and educating those whom they choose to represent. A successful relationship with a gallery requires effort on the part of both artist and staff.

If your goal is to sell work, there is a definite advantage to showing in a space where staff is invested in knowing your

Illustration by K Wayne Harms

story. Imagine the following scenario: I walk into a gallery and am drawn to a work on the wall across the room. I stride immediately to the wall and study the artwork carefully. In an unmonitored setting—like a university gallery or an alternative art space—no one will approach me to tell me anything more about the artist (or the work) than what I can discern from the work itself. Maybe there will be a posted artist's statement. I may love what I see but talk myself out of buying it because no one was around to encourage a sale.

On the other hand, if artwork hangs in a commercial gallery complete with staff, the scenario is quite different. In a good gallery, a staff person waits patiently while I peruse the work and then approaches me, asking whether I would like to know more about the artist. I may be in a hurry and defer, but it's just as likely to tweak my curiosity. "Yes, I think I would like to know a bit more," I say. The staff person launches into the artist's story, distinctive qualities of the work, perhaps the fact that materials are unusual or unexpected, and a few

anecdotes told to prove what a fascinating person the artist is. The artist grows more human and likable before my eyes. I understand his or her struggle or aesthetic. I think I would like to support this aesthetic or contribute to winning the struggle. It's a peripheral advantage that I like the work very much and can also afford it. The sale is made and everyone wins.

You may not be ready for gallery representation or choose not to go that route for one reason or another. Or you haven't done it but it's on your list. No matter where you are on the continuum, it's worth it to write your story. Assemble the highlights and fascinating parts into one document. This delineates the script you'll use to talk about yourself effectively later, whether you're asked to do so at a juried exhibition on the spot or are writing a statement you intend to submit formally to a gallery, or if you'd just welcome understanding yourself better!

WRITING YOUR ARTIST STORY

CROSS-TRAINING EXERCISE

The writing you're embarking upon serves as fodder for the above documents. But more importantly, it's the writing from which you'll glean the fascinating parts of your development as an artist, in order to weave the story you'll tell when someone asks about your work. Why should you care about being able to speak at a moment's invite about yourself? Because articulating your story is inextricably meshed with feeling good about yourself and the artwork you produce. It's another aspect of strength training!

You may already have written an artist's statement or a bio (biography) or even a résumé. Many artists who show work publicly have these documents on hand. But if you're new to this experience, no worries. Writing is the perfect place to start. Just go forward from here. And even if those documents already exist, do this exercise anyway. It stirs realizations about your life and motivations you can't get any other way.

For the record, the typical artist's statement varies, based on the artwork and the exhibition or venue requirements. A statement about one piece may not be appropriate for other works in progress.

A bio is a bio; once it's set, older information may fall off as new events are added, but it's formulaic and answers three questions:

What is your experience?

Where have you shown your work?

What are other related highlights of your artistic path?

Not only does the bio answer these questions, it addresses them in under 250 words, please!

GETTING STARTED

There are three parts to this writing assignment. Eventually the three parts will be distilled to three paragraphs, but to worry about that now would be getting ahead of ourselves.

Don't edit as you go. Stream of consciousness is good. Work from the subject heading and the question asked. Write each part separately from the other two. Get this information down on paper. Edit after the rough draft is done.

Most people appreciate a map; it helps to know where we're headed. So this is your map: After you've written about history, process and content, I'll show you where to look for the thread that binds it all together succinctly. I am 100 percent sure it's there. But you can't discover it without writing, any more than you can imagine the special effects in a movie without actually seeing it.

1 HISTORY

Who are you and what physical path has your life taken? The quantifiable stuff. Your family, schooling, physical addresses on the planet. Siblings? The trajectory of what you liked to do as a kid, how you spent your time as a teenager. Jobs? Schooling? Studies? Marriage? Children? You might think this isn't relevant, but I beg to disagree. Just write it down. From birth to where you are right now.

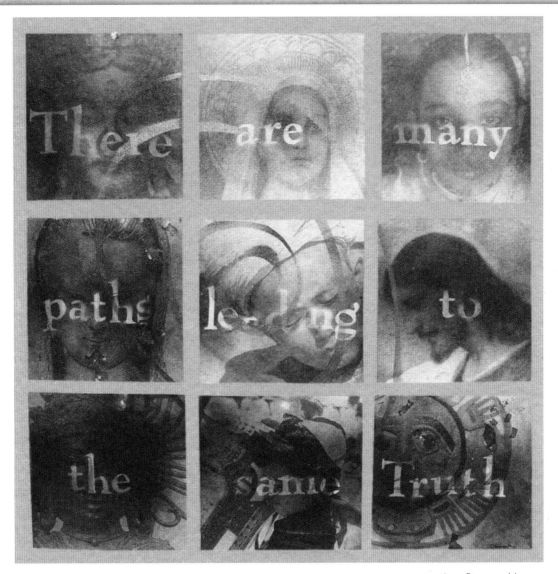

Jane Dunnewold, 2002

2 PROCESS

How do you work and what do you love to do? This is the alignment aspect of the writing assignment. You've already done some of this work as a part of chapter 7's assignment. Again, no need to edit. Just write down how you work and what processes or techniques you find yourself using consistently (as relates to your art practice, that is).

3 CONTENT

What do you care about? This is your passion, also visited in chapter 7, and it isn't cheating to go back and reread what you wrote then. Might be color. Might be war. There's a lot in between, and it's all good. Just write it down.

CHECK IT OUT

If you're parsimonious with words and get to the point quickly, terrific. But it's likely the writing will take time. Don't worry about what's next. I'll provide direction (with examples) on how to distill writing in chapter 9, in order to help you edit what you've written. For now, have fun! Get to know your fabulous, fascinating self. You're distinctive.

ARTISTS RESPOND

As evidence of the positive side of the humility message, not the shaming ones I also received, here is a picture of that child. — Jeanette Davis

The paragraph in the instruction that spoke to the early humility lessons so many of us receive was spot-on. Thank you for addressing that. It's a really tough one for me in terms of old tapes. It hits at the very foundation of the early socialization experiences that shaped my inner critic, the one that opens the door to the Committee.

Restarting the journaling/writing process at this particular time of life is a deepening experience. I did a lot of journaling when I was raising my kids and struggling with a bad marriage. It was helpful then, as it is now, but in a different way since I am now looking back at who I was then, but also to way back before then, to earlier stages of life, and after that time, to who I am now. I often felt tearful while writing this assignment, my heart full with emotion, looking back with genuine love and tenderness at earlier events.

The understanding that comes from life experience and passage of time provided the kind of depth I didn't have then. I am thankful for new insights and understanding about my personal history. Artist-statement material or not, it certainly provided recognition of all the grist in my story.

❖ Jeanette Davis

Judge
Jane Dunnewold, 2008
12" × 36" (30cm × 91cm)
Paint, photo transfer, dye, stitching
on silk broadcloth fused to felt

CONCLUSION

An artist wrote to me about the difficulty of including "bad stuff." Another wrote, saying she'd mainly written bad stuff. When she reviewed her writing, she decided to go at it again from a positive angle. If anything, reading what you've written illuminates whether you've cast your life in either a positive or negative light. Perhaps this is an opportunity to revisit events and catch a better balance.

When my father died, I was out of kilter. The last years of his life (before he was institutionalized and dementia thrust silence upon him) were very hard. Bad things happened. I was carrying a big, fat lump of anger around. After the funeral, good memories gradually resurfaced. Being angry and frightened by the last years of my father's life subsided. I remembered many good things about his personality. His strong capable hands and his larger-than-life laugh. His commitment to justice and great enthusiasm for cooking on a campfire. Healing means reconciling. It's the forgiving that returns internal peace.

Both good and bad events shape our lives. You're not required to write hard stuff. You get to choose what to tell. But referencing the fact that life isn't perfect, that there've been challenges in your life, is a gift to others. It's an acknowledgment that we are all part of a human family that is both fragile and resilient, vulnerable and stalwart. When you engage your Artist Self to tell your stories, it's a brave gift.

Each of Us Is Fascinating,
PART II

NOT ALWAYS A PART OF THE TRIBE

I shared this poem with my sister and was surprised when she thought the poem was incredibly sad. Sad had never occurred to me! I thought the poem should be titled "The Artist's Manifesto." My real discovery was that I always assumed my beloved sister understood me, when in fact, she only understood me up to a point.

I am sharing this because I think it will sound familiar. We love the people who are our Tribe, and they may love us dearly, but that doesn't mean we understand each other. Being called to make art isn't always easy, rewarding or lighthearted. Sometimes it distances us from other people; if it isn't a story they recognize, they don't get it. But that can't stop us from making.

When they say Don't I know you?
say no.

When they invite you to the party
remember what parties are like
before answering.

Someone telling you in a loud voice
they once wrote a poem.
Greasy sausage balls on
a paper plate.
Then reply.

If they say We should get together.
say why?
It's not that you don't love them
anymore.

You're trying to remember something
too important to forget.

Trees. The monastery bell at twilight.

Tell them you have a new project.
It will never be finished.

When someone recognizes you
in a grocery store nod briefly and
become a cabbage.

When someone you haven't seen in
ten years appears at the door,
don't start singing him all your
new songs.
You will never catch up.

Walk around feeling like a leaf.
Know you could tumble any second.
Then decide what to do
with your time.

◈ *Naomi Shihab Nye*

CARING ENOUGH TO BE CLEAR

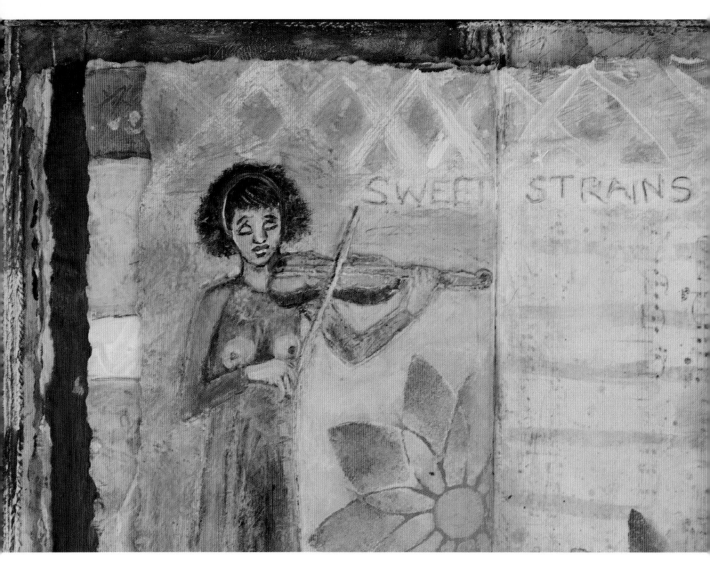

Art by Carol Wiebe

If you completed the work proposed in the last chapter, you came face-to-face with your past. Many of us had wonderful, encouraging parents; many of us didn't. Or our parents were conflicted. In any event, we're here. Making sense, or recognizing that part of your story will *never* make sense, is at the least, a healing. Maybe you recognize parents who did the best they could with what they had, even if it wasn't enough. Maybe you finally understand why people behaved the way they did. Maybe you deserve to be totally pissed off about something that happened to you, but you decide carrying the burden around has compromised your stamina.

Maybe it's time to lay the burden down so you have more energy to make art. Or maybe it's time to use your angry energy to make art that can heal you.

Which brings us to forgiveness, perhaps a stretch as a topic within the context of Creative Strength Training, but relevant. May I point out that no one is able to demand forgiveness. Forgiveness can only be offered. And so, writing your story is an opportunity to rebelliously forgive. Free up your energy and spend it making meaningful and ecstatic art, whatever that looks like to you.

Life here in Earth School is different for each of us. No matter what your experience is or has been, the best thing you can do is keep writing. And making.

Another use of your history/process/content story? Share it with someone else, in order to connect authentically with them. Say to someone you love, respect or are in a relationship with, "Hey, I wrote this because of a book I read, and I want you to read it." The story is there in plain writing and is an opportunity to open a discussion impersonally. When something's on paper, the reader is less likely to take it personally. The verbal posturing isn't a factor.

And for those of you who have figured out who your support staff is, nothing can be better than sharing what you've written so it can be celebrated. You might even encourage a friend to write his or her own version of history/process/content.

And yeah, you may not be ready to share what you are writing. Maybe you don't want to put it out into the world. But at least *you* know what's what. And knowing "what's what" yourself—that's huge.

HOW TO DISTILL AND EDIT YOUR STORY

CROSS-TRAINING EXERCISE

WHAT TO GATHER

◈ favorite writing implement

◈ something to write on (journal or loose paper)

Let's revisit the process so far. In the last chapter, the assignment was to write the "shitty first draft" about the following topics.

PART 1: HISTORY

Who are you and what physical path has your life taken?

PART 2: PROCESS

How do you work and what do you love to do?

PART 3: CONTENT

What do you care about?

Now we'll go on to the refining part of the process.

What you love to do is personal. This unknown folk artist spent hours building elaborate birdhouses, all crammed together in his urban garden.

1 REVISIT YOUR HISTORY

Your history may be two pages or twenty. No matter. Read it all, then analyze the story as though you never met yourself. Think of this as the CliffsNotes version. Look for the threads that connect your experiences, personality traits that appear to create a pattern.

Here's my own example:
I wrote at length about loving to play outdoors as a kid and sitting under quilt frames as a child. Hearing women share their experiences. Making a dress in ninth grade that got a D because I stapled the zipper into the garment! Had grandmothers who sewed and knitted. Never wanted to sew or have anything to do with textiles. Went to college to major in psychology

and religion and wanted desperately to escape from the small-town environment.

Fast-forward through getting a degree, considering graduate school. Marrying. Feeling isolated in a town where I didn't grow up and knew no one. Various odd jobs from teaching kindergarten to waitressing. Started embroidering to pass time. It was fun. Which led to a class in fabric painting. And then a real love of painting and dyeing fabric because of a class with a local teacher. Began taking classes to get better at painting, color and design.

The first draft was written with many details, none of which need to be included here. You get the idea.

The distillation of those life events reads: "I never thought I wanted to work with textiles. As a young girl, I sat under the quilt frame and listened to gossip. My mother made all our clothes and was determined I would learn to sew. My ideas were different; I studied religion and psychology as an undergraduate and went on to teach kindergarten and take a variety of odd jobs. How surprising to discover in my thirties that I loved to embroider, which I took up after moving far from family and friends, as solace for being alone. That love fostered interest in other textile processes and led me to where I am now: dyeing fabric, creating garments and somehow carrying forward the tradition of the women who sat around the quilt frame."

The threads I noted when I distilled my story? I loved textiles at an early age, and that eventually came full circle. Also, I was headstrong and always wanted to do things my own way, which contributed to the circuitous path that brought me back to making.

In order to capture highlights of your story, you may have to write it several times, gradually reducing it to the most important threads. Keep some of the stories, told in a sentence or two. They are the parts that are unique.

CHECK IT OUT

A reminder: Editing translates your big, small, gorgeous, disappointing, wild and steady set of life experiences into a story you can share. Maybe some people will stay up all night listening if you are an exemplary storyteller, but 90 percent of the time it's important to cut to the chase or you'll lose your audience. So be prepared.

The disclaimer: We are all delighted to encounter people who love what we do and want to hear more. When that happens, thank your lucky stars and feel free to riff from the three-paragraph distillation you are creating. Those conversations are the icing on the cake of your creative life.

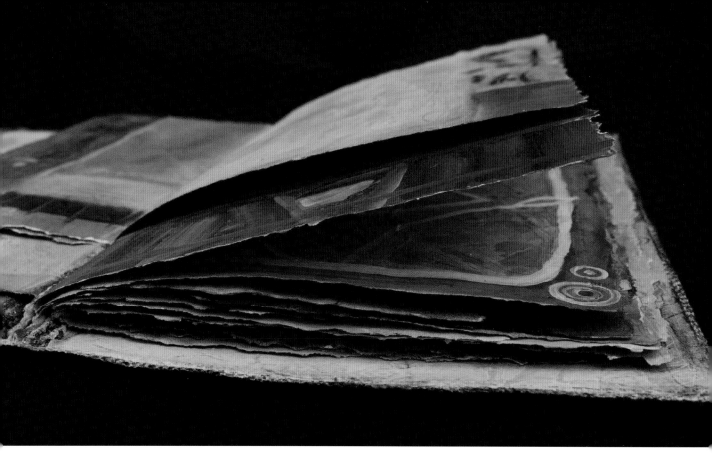

When Carol Wiebe writes about process she explains multifaceted techniques—including painting, monoprinting and bookmaking—in words that will help to educate her audience.

2 REVISIT YOUR PROCESS

Read what you wrote about process. This is usually easier to edit; the same strategy applies. Reduce the techniques mentioned to a manageable read. Remember not everyone knows what your processes are, so don't abbreviate. If needed, provide a brief explanation of terms. Most people understand painting, but if you work with encaustic or lamp-worked glass or other less familiar materials, it's a good idea to describe the process briefly.

For example:

Example #1:

"Although I experimented with painting, drawing and encaustic (hot wax applied to a hard substrate), my heart sang when I learned to dye cloth. I currently use an ancient Japanese dyeing process called shibori (fabric wrapped tightly with thread or rubber bands, then dyed in a colorful dye solution) to create elegant lengths of silk fabric. I turn these fabrics into distinctive works of art. I use silk because it's lustrous but also very strong."

Example #2:

"My background is rich with experiments in many mediums, including painting, dyeing fabric and throwing ceramic pots. But the first time I picked up a camera and trained the viewfinder on the flowers around me, I knew I was hooked. I use digital photography, enhanced with effects from Adobe Photoshop, to create abstracted, larger-than-life tributes to the natural world."

Example #3:

"My world rocked when I discovered I could load my own photos to a print-on-demand site that would transfer them to fabric. The collages I make now are a combination of paper, fabric and digital imagery."

Note: Avoid removing the richness of your process by eliminating too many details. Look for unusual, funny or surprising things about your combination of materials and processes, and mention those.

3 REVISIT YOUR CONTENT STATEMENT

This may be the easiest paragraph to revise. The same strategy used above applies again. Reduce what you wrote to the clearest, most succinct version of what you care about.

For example:

"No matter what medium I choose, my goal is to bring beauty to the world by combining colors and patterns in ways that delight the eye. My paintings are a prayer. Each stroke offers beauty and hope to a world that desperately needs both."

Or:

"I love flowers and plants. My painted silks honor the natural world in all its infinite variety."

Or:

"While I've studied a wide range of art processes, my subject matter remains consistent. I am intrigued by the serendipity of the shibori process, and I love relating my work to the human form. There is nothing more satisfying than creating distinctive clothing that delights the wearer as much as it delights me!"

When the history, process and content paragraphs are combined, the statement reads something like this:

"I never thought I wanted to work with textiles. As a young girl, I sat under the quilt frame and listened to the gossip, watching the needles poke through the cloth sandwich above my head. My mother made all our clothes and was determined I learn to sew. My ideas were grand. I studied religion and psychology as an undergraduate and hoped to become a therapist. But instead I got married, taught kindergarten and took a variety of odd jobs. How

surprising to discover in my thirties that I loved to embroider, which I took up after moving far from family and friends, as a distraction to being alone. That love fostered interest in other textile processes and led me to where I am right now: dyeing fabric, creating mixed-media artwork and somehow carrying forward the tradition of the women who sat around the quilt frame.

"Although I experimented with painting, drawing and encaustic (hot wax on a hard substrate), my heart sang when I learned to dye cloth. I currently use a Japanese dyeing process called shibori (fabric wrapped and bound tightly, then dyed in a colorful dye solution) to create elegant lengths of silk fabric. I sew these fabrics into distinctive artwork, which also incorporates printing, paper and sand. I love silk. It is lustrous and strong.

"While I've studied and teach a wide range of processes, my subject matter remains consistent. I am interested in how the natural world intersects with the human one, and I am commenting visually on these relationships in ways that resonate with viewers."

ARTISTS RESPOND

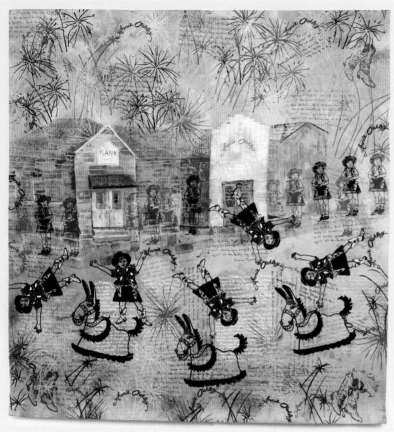

Me and Annie Oakley
Judy Cook, 2015
42" × 36" (107cm × 91cm)
Screen printing on hand-dyed silk

HISTORY

My art career began the day I drew my first stick figure. Mom declared me an artist and it stuck. She did a lot of art. I loved it when she drew with us. I think I learned how to draw because I couldn't stay in the lines of the coloring books, so I drew my own lines. When I was five Mom became the town librarian. I went to the library after school and became a voracious reader. I loved the bookmobile. Driving around taking books to people was the coolest job in the world.

I have been doing some type of art my whole life except for a brief period in college when I got stuck, like many of us do, by a critical teacher. After college, I found my way back to art, taking watercolor classes just for me. And I met my husband. I taught him to see sunsets. He taught me to notice birds and to fish. Our daughter enjoyed my art projects. We did a lot together. She helped me create clown props, paint murals and make school play scenery.

I always regretted not getting that degree in art. I worked as a computer programmer but fulfilled my daydreams by taking every art class I could find. I finally did get that degree and also studied surface design through workshops.

PROCESS

Expanding my knowledge of the world is important. Writing, illustrating, making artist books and telling stories on cloth makes sense of my life. Researching a topic excites me. It's like diving into pools of information. For instance, in creating a book of family stories set in Oregon, I found maps, historical photos and images of train tickets from the 1920s. In another project on tinnitus, I researched color as it relates to musical pitch and also to quantum physics. My research provides mental images and symbols, which then translate onto paper or cloth.

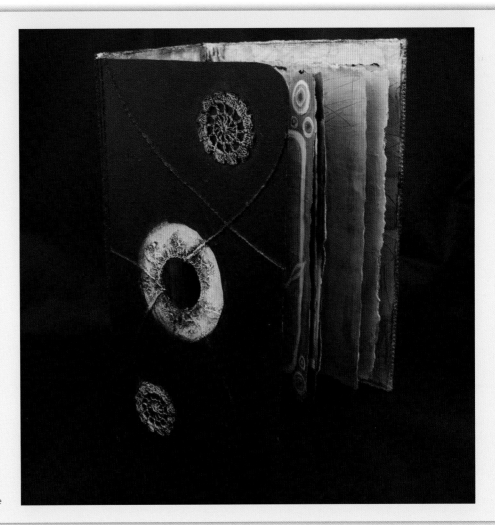

Art journal by Carol Wiebe

CONTENT

There is a difference in creating a product to sell and using creative skills to express personal voice. I've found making art to sell is not enough. There had to be more than creating the same thing repeatedly, at least for me. It's a balance.

❖ Judy Cook

PROCESS

If I were to describe how the courage to call myself an artist presented itself, it would be a novella. My greatest catalyst for launching an intentional art practice was the discovery of mixed-media work. It suited my wide, varied skill set. Then I discovered quilted paper.

Others were making paper "quilts," but they were pasting or stitching cut shapes onto a base. I developed methods to quilt an entire paper sandwich. I used my painted papers, or printed digital designs, to form that base and elements collaged to it. I also developed a paper appliqué method with hand-stitching and crochet for edging and decoration. The results were painted with acrylic paint. I continue to refine and add processes to further this art form. It's so thoroughly satisfying I call it "spiritual practice." It facilitates the exploration of inner memories, drives and emotions, and allows me to express them in a way that is supportive and surprising.

CONTENT

Current themes include time eroding/ beautifying objects, embracing imperfection and perceiving wonders that permeate our lives. I write poetry to accompany my works, further elucidating what they attempt to reveal. The muse is a worthy companion who has never left my side.

❖ Carol Wiebe

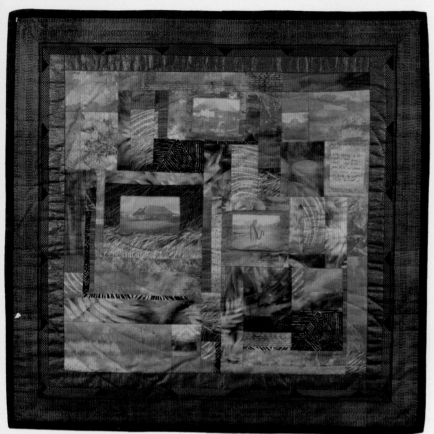

Flora's Friend
Valerie Hearder, 2004
26" × 27" (66cm × 69cm)
Photo transfers, dye from
indigenous South African leaves
on hand-quilted cotton

HISTORY

I was born in a lush tropical city on the Indian Ocean—a fourth-generation South African. Steeped in stories of legendary African adventures, I spent much of my life outdoors enjoying natural surroundings. Learning to sew was a disciplined skill, and I did fine embroidery at twelve years old. As a teenager I made weekly (forbidden) excursions into vibrant Indian and African marketplaces to bargain for indigo shweshwe fabrics, sarongs, beads and spices.

At twenty-three I left the tropics and made a dramatic relocation to Canada's Arctic with my husband. We moved to Labrador where I worked for several years with First Nations craftswomen. We settled in Nova Scotia and I focused on being a craftsperson/ artist and mom. A teaching career developed and I taught internationally and authored two books on fabric landscapes. Recently my focus has shifted back to South Africa, and I run a small entrepreneurial business importing narrative textile arts from women's groups in South Africa. Their stitched stories in cloth give me deep insight into their lives. This business evolved into leading annual cultural tours to South Africa.

CONTENT

Making wall art has linked me to early experiences of stitching and textiles.

Busy Negative Space
Pippa Drew, 2014
16" × 16" (41cm × 41cm)
Thermofax print, textile
ink, fiber-reactive dye
on cotton

Work is often autobiographical—exploring issues of displacement, belonging and symbolic connecting to the landscape. How do we move and yet still feel rooted to a primary landscape? My childhood landscape, like a neural pathway, influences my inner vision and expresses itself in subtle ways.

❖ Valerie Hearder

PROCESS

When I develop an idea for artwork, I refer to other artists to see how they solve problems and achieve balance. Matisse is currently a touchstone. Influence like this is a slippery slope if it feels like copying, but it helps me shoot higher as long as I remember to trust my own voice. I use shorthand sketches and notes, recording ideas that pop into my head, to be sure my ideas are my own. Cross-fertilizing color, shape or an image from my own idea bank leads to deeper internal connections within a series. Looking at spontaneous images leads to the next idea, like following a trail of crumbs. I've also started reading and researching more. It's fascinating to observe how visual work in progress is enriched by wider knowledge.

❖ Pippa Drew

Departure
Mary Elmusa, 2015
50" × 24" (127cm × 61cm)
Collaged and painted collograph
on machine-stitched and quilted
cotton fabric

As I worked on *Departure*, I seriously considered the topic of getting rid of the judging voices. I used the same letter forms as I did on my chapter 2 Notan exercise. In this piece, I see the patterned spaces and letters mostly departing, breaking up, leaving the format, sometimes being hard to recognize from the background—

hidden—just like the internal voices we focused on in that lesson.

Regeneration was completed shortly after the course ended. I'd realized that cropping an image, then building another image from the cropped section, suited my intention and purposes. *Regeneration* was

derived from a section of *Departure*. Original images were manipulated and printed digitally on cotton fabric. The piece was also painted, embroidered and quilted. The concept of regeneration and transformation was intended to be made visual by the methods, symbolism and color.

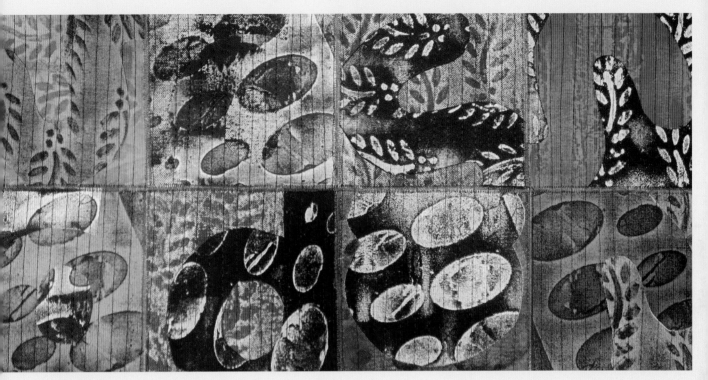

Regeneration
Mary Elmusa, 2015
24" × 48" (61cm × 122cm)
Collaged and painted collograph
on machine-stitched and quilted
cotton fabric

CONTENT

I'm interested in visual language's
ability to interpret inward spiritual and
emotional states. I want my work to
portray essential and universal truths
I've realized through spiritual interests,
awareness and living a full life. The
solitude necessary in creative work

is soothing, a time when I can listen
to my own thoughts and follow the
inner guidance I seek. I honor Georgia
O'Keeffe's quote, "Making the unknown
known is the important thing"

❖ Mary Elmusa

CONCLUSION

Now it's your turn. Cull what you've
written and give it your best shot.
Edit more than once if it's hard to get
numerous pages of writing down to
a single paragraph. Read it out loud,
which helps. And remember, Authentic
trumps ArtSpeak. Are you ready?

Untitled (detail)
Vivian Mahlab, 2014
65" × 80" (165cm × 203cm)
Mixed media, hand stitching on
cotton over batting

Discovering Grace Through Acts of Making

ACTUALIZED MAKING

Making begins as play. Something you see in a book and decide to try. Something a parent taught you. Inventions with paper and string. A needle and thread. A hammer, a piece of wood, some nails. Aimless experimenting or directed learning. It all starts with something.

Next, you want to get better at whatever you're pursuing. Your competitive streak surfaces. Or you're tired of failing. Or you just like the idea of being better at whatever's drawn you in.

Eventually you recognize how much "making" means to you. You enjoy it. You even love it. Your creations and process? Always in the back of your mind, percolating, even when you aren't actually hands-on. Even when Life forces you to take a break or shift gears.

The actualized stage of making? A deep recognition that the ability is in you. And it isn't leaving. Lapses of time don't scare your ability away. The connection is embedded deep within you. A good friend waiting for your return. Effort cultivates this ability, then come the rewards. A grace that's always available. All you have to do is keep showing up.

The Way It Is
There's a thread you follow. It goes among
things that change. But it doesn't change.
People wonder about what you are pursuing.
You have to explain about the thread.
But it is hard for others to see.
While you hold it you can't get lost.
Tragedies happen; people get hurt
or die; and you suffer and get old.
Nothing you do can stop time's unfolding.
You don't ever let go of the thread.

◈ William Stafford

YOU HAVE THE TOOLS
TO BE AUTHENTIC

BEING YOUR AUTHENTIC ARTIST SELF

I pondered what to write for your consideration in this closing chapter. Inventorying topics we've discussed seemed like a good idea. Wrapping up with an overview. But what else?

I meander when I'm not sure what to do, so I meandered over to the studio, hoping to secure direction by working awhile. Engaging hands, so thoughts could organize behind my eyes.

My inspiration was on the bulletin board, right next to the studio door. "You are perfect the way you are . . . and you could use a little improvement." —Shunryu Suzuki Roshi.

This quote is a favorite of mine. It doesn't have anything to do with the spiritual persuasion of Suzuki Roshi. You can probably tell from the quotes and poems I've shared that inspiration comes from all over the place! I include it because I hope it will resonate with all of us who want to get better at this art-making thing. I like the wryness of the quote. It's so tough for us to accept the reality of the words. Hard to admit every day we're basically beginning at the beginning and trying to improve!

It's simply a matter of showing up, then putting all the tools you've cultivated as part of building stamina to good use:

» Employing writing to find a path, or to further development

» Engaging the Rebel to manage challenges of time constraints, materials or feedback from others

» Calling out negativity when you encounter it, whether it's the Committee or your own self-doubt or a combination of both

» Revisiting alignment and recalculating—a lifelong task

» Discerning distinctiveness as part of alignment

» Working with your story so it serves you internally (how you see yourself) as well as externally (what you show to others)

It's a positive process; I hope you see that for yourself. And there are several key realizations to acknowledge.

YOU HAVE THE TOOLS

The first one to recognize is that once it's in you, it's in you. Before, you may have feared drying up or being out of touch, or feared you would never find your way back to your work. But now you know about the thread. It's always there. So let that worry go. You've got the tools to find your way. They are your symbolic compass and flashlight.

HAPPINESS AND IMPERFECTION CAN COEXIST

Number two? The paradox: You'll never be good enough, but you can still love what you do. It's a version of Sukuzi's quote. If you are actively engaged by your work, you will love it. And even though you may be in alignment, you'll always see the tiny flaw or where a piece could be stronger. Good. It means you'll keep making, because as elusive as perfection is, most of us still strive to achieve it. When we achieve it—should we be so fortunate—it's unlikely we'll be content. There's always another perfection to seek, more work to do.

YOU CAN'T ESCAPE YOURSELF

Number three? A dawning realization that the flip side of having it "in you" is not being able to get away from it! You're birthing an Artist Self and the birth canal only goes one way. I could quote an old Wiccan proverb, "Be careful what you ask for, you might get it," but what good would it do? You've already asked.

My best piece of advice at this stage is to go for it. Surrender to the process. It goes like this: If you have to accept that you are fascinating because you've accepted that everyone is fascinating, you have to accept that this process of building stamina, working awhile, seeing a need or opportunity for change, recalculating and starting again, is an impersonal, universal process. It's the same for everybody. Isn't that comforting? You're not on the same spot on the continuum as others—everybody's station is different and changing—but we are all still on the same continuum in the end.

If you embrace this idea wholeheartedly, you may feel a rush of relief. You've realized every person you encounter is having some sort of experience with making that you can relate to. When you encounter meanness, dismissiveness or a disconnect, you can realize it's not about you. It's a matter of where the person is on the continuum.

Which leads to settling into yourself. Liking who you are. Knowing you need to get better but feeling OK with it. Which leads to grace. Grace isn't something you can demand or manifest by yourself. You did the work suggested in the earlier chapters. You see how far you've come and how much more there is to do. The potential exists for this reality to cease being an impediment or an intimidation to growth. Instead you can begin to view it as part of the natural progression of things, an exciting exploration that never ends, a process to choose to enjoy. And when you do, the studio will be filled with grace. Then the only appropriate response is "Thank you."

I would be remiss not to talk about the power of being an artist one more time. I offered the analogy of putting on your own oxygen mask before you help anyone else on the plane. That's what you're doing when you build stamina through strength training. Having built stamina affords you the opportunity to grab an even bigger challenge, positioning your work to make a difference in the world whether by sharing beauty, commenting on justice/injustice or making people laugh.

It's an honor and a privilege and one you can grab any time you want. Mainly it comes from being willing to put your work out there so others have a chance to know it and to know you.

The anonymous author of this passage said it as well as anyone could:

All of our activities should be influenced by the pleasure,
not the pain, principle. We have not come into the world to suffer,
or to inflict suffering.
Every day do something that is good only for you. Selfish?
No. Self-possessed.
Balance it out by doing something equally good
for the benefit of all
This will depend on your opportunities.
Only you will know what you can do.
If you are an artist use your power to be original—to try to heal
the wounds you see around you.
Everything we do needs passion to be done well.
Passion is precious. It indicates good mental health.
Use it as an important energy source all day.

MOVING AHEAD WITH THE PLAN

CROSS-TRAINING EXERCISE

We often hear someone say rather wistfully, "I guess all good things come to an end."

But isn't it terrific that we don't have to say that here? Your quest to be a stronger, more authentic and compassionate artist is not ending just because you've come to the end of this book. Depending on where you are on the continuum, you are either just beginning or joyously continuing. And it's all good.

Now's the time to develop a few strategies, decide whom you will confide in, where you will seek support and how you will continue to focus on making distinctive, heartfelt work. I applaud all of those efforts and hope to hear from you. I'd love to know how it's going!

WHAT TO GATHER

- ◈ favorite writing implement
- ◈ something to write on (journal or loose paper)
- ◈ mirror (optional)

1 WRITE

Write a strategy for strengthening and continuing the progress you've made by working with this book. Make a list. Write a paragraph. Be specific. Generalities won't get you anywhere. What are your specific intentions? Write them down.

2 RECITE

Read your list or statement out loud to the mirror or to someone you trust. If we were in a classroom, we would read our intentions to each other, but we don't have that luxury. It's important to verbalize your intentions. Get your heart and head working in tandem, then seal the deal by speaking it out loud.

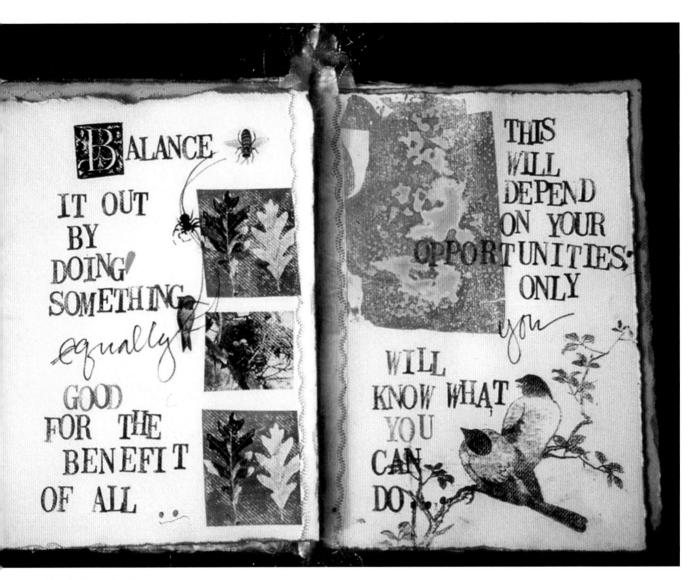

Untitled artist book
Jane Dunnewold, 1998
9" × 11" (23cm × 28cm)
Handmade paper, photo transfers,
gold leaf, paint, thread

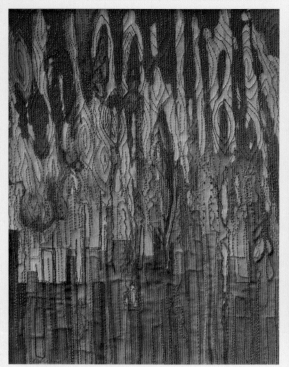

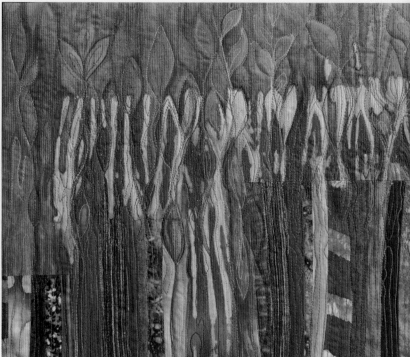

Emerging 1
Adriene Buffington
10" × 8" (25cm × 20cm)
Artist-dyed fabric, fabric pastel,
markers and acrylic paint, free-
motion machine stitching, fused
appliqué on stretched canvas

Emerging 3
Adriene Buffington
11" × 14" (28cm × 36cm)
Artist-dyed fabric, strip-pieced
prints, fabric pastel, markers and
acrylic paint, free-motion machine
stitching, fused appliqué on
stretched canvas

These art quilts are from a series expressing the process of emerging. In these pieces, there is a transitional place of chaos and deconstruction between an orderly, linear foundation and an organic, spontaneous emergence.

I have been going through this messy spiritual process awhile: questioning what I was certain of, feeling frustration and grief as so much of my foundation broke apart, but growing out of the confusion into a season of new life, hope and peace. All three phases exist simultaneously. As much as I would like to remove the mess and escape constraints, they are as much a part of my story as the free-flowing beauty that is emerging. The challenge lies in integrating, even celebrating, the structure, the freedom and the chaos.

Dreaming is my masterpiece in this series. The dreamer is surrounded by confusion, yet is at peace. Hoping, but without knowing for sure, there is something beautiful emerging from the tangle. It isn't a rebuilding of the brick-like foundation, although some of those structures remain. The chaos never entirely resolves, but rather than destroying, it generates creativity and life.

❖ Adriene Buffington

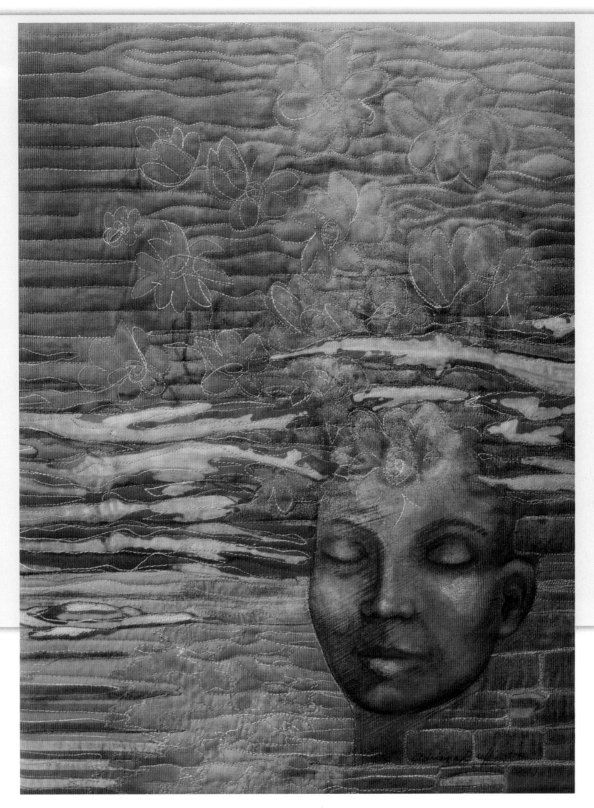

Dreaming
Adriene Buffington
16" × 12" (41cm × 30cm)
Artist-dyed fabric, monoprint, fused appliqué, fabric pastel, markers
and acrylic paint, free-motion machine stitching, trapunto on
stretched canvas

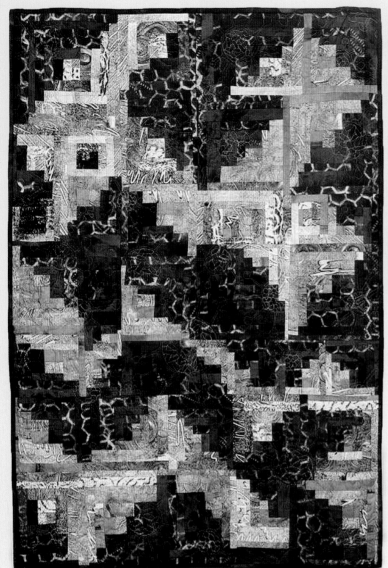

Watershed/Shower Scene
Ali George, 2014
44" × 32" (112cm × 81cm)
Hand-dyed cotton, paint sticks,
textile paint, black pigment,
machine stitching

So here I am, the beginning of a new creative time is ahead. What a journey! Sometimes I kept up and other times I ebbed and flowed and was OK with it because I've learned to be OK with it. I had a deadline approaching for a show entry, and about six weeks into this course I found myself revisiting the concept and execution of my entry.

Watershed/Shower Scene explores the ordinariness of taking a shower, our western culture practice of washing as frequently as society dictates, something we rarely consider. This was set against the reality of how many billions of people do not have access to running water or a shower. Images of bacteria represent what privileged western society scrubs away, while at the same time, bacteria contributes to quite different life outcomes (disease and higher mortality rates) for millions of others. This content was not what I originally planned as an interpretation of "Redirecting the Ordinary," but it was what it needed to be.

My quilt didn't get accepted into the exhibition, but I wrote to the curator to reassure her it wasn't a failure, rather the best work I'd created to date. I think she was pleasantly surprised! And now it's touring in another exhibition.

❖ Ali George

Lonely
Joyce Ritter, 2014
18" × 24" (46cm × 61cm)
Fabric, machine piecing and quilting

It may have seemed as if I'd lost interest, but to my amazement I found I was just very bored with fabric. After dyeing forty yards of cotton I stopped and considered my intention. To piece was out . . . too slow. I have millions of ideas while I'm laboriously running cloth through the washing machine. Too bad because I just bought a new Janome sewing machine!

The work I did in the past was becoming more three-dimensional. At the time I hated how fabric fades. After reviewing my old work and seeing even more fading, I saw this was no longer my direction.

I also need to learn new things. There's an excitement in handling new materials, new tools. My very capable hands want to build, erect, birth.

For the last month I have been taking ceramics and loving it. It's my second time around with clay, and I am just burning with ideas—exactly what I hoped to accomplish by studying this course. And now I can apply the assignments to new mediums.

❖ Marion Ongerth

Leaving
Joyce Ritter, 2014
24" × 24" (61cm × 61cm)
Fabric, machine piecing and quilting

My three mantras are make time and take time, use what you have, and go for the WOW. As long as I stick with these, I find the content falls into place on its own.

When my friend Roma's cancer came back, I was working on *Lonely*. Life imitated art. People stopped calling and she was trapped in her home by her illness. I was part of the caretaking process and knew that Roma's daughter wanted her mother to talk to a chaplain. Roma was not an introspective person. The talk was uncomfortable.

I stayed true to the *Make/Take* time idea and went to work on my quilt *Leaving* and shared it with her. "It's much brighter than I expected," she said, and the conversation took off after that.

I made another piece – *Passage* (not shown). For some reason I left the format size I'd picked for the series and went really big to make two gold doors opening out (all the other doors opened in—or not at all) with the word *AWE* in the center of the opening. Lots and lots of WOW quilting. Gold mesh, metallic threads. I mean, I went for awesome. Roma's comment: "It's bigger than I expected." To which I was able to respond "Next to our birth it's the biggest thing that ever happens to us." Again, we talked.

I was with Roma, her daughter and her daughter's partner as she died. It was a peaceful death. I like to think that the quilts helped in some small way. And since the make/take routine was embedded in me at this point, I was able to go to my studio and mourn. I made a whole cloth quilt with a little bit of paint. It seemed fitting after the loss of one of my best friends to work with basic needle and thread. Of course, being who I am, I had to overdo the thread, but it was a good tribute to a good friend.

❖ Joyce Ritter

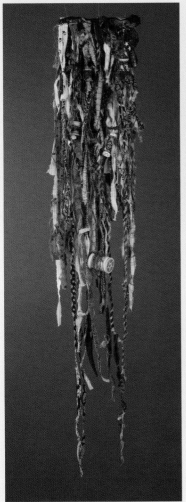

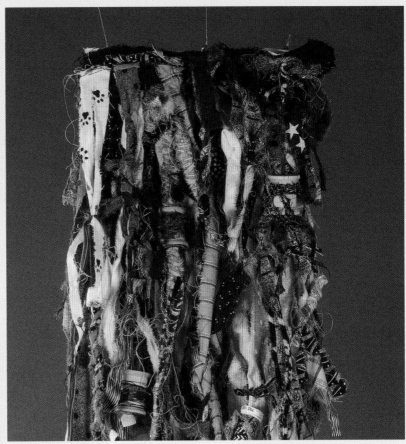

A Torn Thing Blowing
Clairan Ferrono, 2015
64" × 8½" (163cm × 22cm)
Fabric, thread, spools on wire armature

CONCLUSION

What does not exist looks so handsome.
What does exist, where is it?
An ocean is hidden. All we see is foam,
shapes of dust, spinning, tall as minarets, but I
want wind.
Dust can't rise up without wind, I know,
but can't I understand this
by some way other than induction?

Invisible ocean, wind. Visible foam and dust:
This is speech.
Why can't we hear thought?
These eyes were born asleep.
Why organize a universe this way?

With the merchant close by a magician
measures out
five hundred ells of linen moonlight.
It takes all his money, but the merchant
buys the lot.
Suddenly there's no linen, and of course
there's no money,
which was his life spent wrongly, and yours.
Say, Save me, Thou One,
from witches who tie knots and blow on them.
They're tying them again.
Prayers are not enough.
You must do something.

Three companions for you:
Number One, what you own. He won't even
leave the house

for some danger you might be in.
He stays inside.
Number two, your good friend. He at least
comes to the funeral.
He stands and talks at the gravesite.
No further.

The third companion, what you do, your work,
goes down into death
to be there with you, to help.
Take deep refuge with that
companion, beforehand.

❖ Jalāl ud-Dīn Rūmi
 translation by Coleman Barks

CONTRIBUTING ARTISTS

Tara Alexander (United States)

Tara is a mental health therapist living in Colorado Springs, Colorado. Her passion for mental health influences her art because she asks the viewer to "step inside" and observe how pieces change or influence us. Tara prefers to hand-paint on wall-sized textiles, finding anything smaller too confining. The largest influences on her work are her world travels and exposure to other cultures, including her time living in Europe.

Mary Ann Ashford (United States)

Mary Ann's love for fiber arts began with a Christmas card that came with instructions for making a miniature quilt. She accepted the challenge, but it wasn't until she retired that Mary Ann began taking workshops in appliqué and quilting. As she created quilts, her approach became more free-form. She started to explore the world of surface design, hoping to find methods that suited her intuitive approach. To that end, Mary Ann is now experimenting with a variety of surface design motifs and techniques with which she hopes to voice her own story.

Louise Bateman (United States)

In 2003 Louise discovered the world of surface design and art cloth, and her artistic self exploded with possibilities. Dyeing fabric led to dyeing her own yarns, which are woven into yardage and sewn into garments. Louise works almost exclusively with hand-dyed silk yarn, which is woven using a variety of different weave structures. She also dabbles in watercolor, writes haiku poetry and photographs patterns, colors and textures—all inspiration for her work.

Kathryn Belzer (Canada)

Kathryn delights in making dolls, puppets and costumes in a cozy at-home studio, in the wardrobe workshop of the Musquodoboit Valley Bicentennial Theatre and in the Dartmouth studio of fellow artist Margi Hennen. Over many years she has explored and been challenged by Jane Dunnewold's books and classes. It brings Kathryn joy to be included in this innovative project.

Kerri Boase-Jelinek (Australia)

Kerri has lived near a city for most of her life but always in proximity to a beach, bushland or river. With a passion for exploration, at a young age she began capturing natural patterns and textures with her small Kodak Instamatic camera. A whole new world emerged when Kerri's father gave her his Nikon camera one Christmas. Photography and pattern remain central to her practice, which has broadened to investigate intersections between timber, cloth and traditional textile processes.

Adriene Buffington (United States)

Adriene has been journeying through a messy and difficult spiritual process of deconstructing and emerging for at least a decade. Her transition began with feeling discontent with the way things are in contemporary Christianity. This led to questioning what she had been sure of, and rejecting much of what is considered essential doctrine. Adriene is emerging out of this confusion into a season of new life, hope and peace—her art-making a part of the process.

The challenge lies in integrating, even celebrating, the structure, the freedom, and the uncertainty; creatively keeping each part of her story alive as she expresses both beauty and chaos in her art.

Barbara Bushey (United States)

Barbara has been making art quilts for nearly thirty years. Her work has appeared in many prestigious juried shows, including three appearances in Quilt National. She finds inspiration in the details of surfaces and structures of woodlands and waterways throughout the seasons of the year. She uses the techniques of resist dyeing, quilting, collage and stitching to construct, enhance and emphasize the imagery. In addition to her fascination with the natural beauty of Michigan, Barbara's art is informed by her teaching of art history.

Judy Cook (United States)

A storyteller at heart, Judy combines layers of color and texture with drawing and printmaking to tell visual stories on silk. After retiring from a successful career in

information technology, she earned a B.A. in Fine Arts from the Evergreen State College in 2014. Judy is currently participating in the Art Cloth Mastery Program in San Antonio, Texas. She shows her work at shows and galleries in Olympia, Washington.

Jeanette Davis (United States)

Jeanette is a mixed-media fiber artist from Grand Junction, Colorado. Her first incursion into the art world (experimental filmmaking) was put on hold until her retirement as a clinical social worker/psychotherapist. Jeanette learned to sew and studied fiber arts and surface design, including completion of Jane Dunnewold's Art Cloth Mastery Program. Her work has been juried in numerous national exhibits.

Linda Dawson (United States)

Linda was raised in Kansas but now calls Florida her home. She loves manipulating white fabrics, dyeing them to get wonderful patterns and adding varied techniques to enhance the cloth, mostly direct dye painting and silk screening. Linda's love of flora and fauna shows in much of her work, which concerns the preservation of Florida's natural resources. Her understanding and respect for mathematics is represented in her work, mostly in the form of fractals. Incorporating both nature and mathematics in her work is Linda's goal as an artist.

Pippa Drew (United States)

Pippa earned a B.F.A. from the University of Massachusetts in 1976. Living in San Francisco in the 1980s she produced hand-painted silk scarves, then returned east to attend Dartmouth College to receive her M.A. in painting. Pippa has studied textiles in Indonesia and Japan and taught surface design. She also created the surface design component for Pattern, a mathematics and art class funded by the National Science Foundation for Dartmouth College. Pippa works from her studio in Post Mills, Vermont, where she lives with her husband, George Morris, an acoustic guitar builder.

Mary Hamam Elmusa (United States)

Mary's textile-based work includes dyeing, painting and forms of printing. Unexpected, creative surface design on cloth combined with more precise patterning and sewn construction has become an integrated, authentic process and expression. Pattern plays a vital role in Mary's work as both a carrier of symbolic meaning and representative of the repetitive nature of thought. She honors Georgia O'Keeffe's quote, "Making the unknown known is the important thing." The solitude necessary in creative work is soothing and a time when Mary can listen to her own thoughts and follow that informative inner guidance.

Clairan Ferrono (United States)

Clairan is a full-time artist living in Chicago. Born and raised in New York, she was educated at Syracuse University, Oxford University and the University of Chicago, and spent twenty-five years teaching English, writing and ESL in Chicago and New Orleans. Clarian currently creates mixed-media fiber collages and drawings. A Professional Member of the Studio Art Quilters Associates, she was the managing curator of two international exhibits. Clarian is the founding member of Fiber Artists Coalition, an exhibiting group. Her art quilts have appeared in numerous books and hang in many private collections.

Mindy Fitterman (United States)

Childhood fascinations in Pueblo, Colorado, with paper and textiles along with geometry persist to this day for Mindy. After studying textile design, she switched gears to become a nutritionist, leading to a thirty-five-year career in public health, during which art remained part of the picture. Mindy's favorite techniques include fussy cuts, English paper piecing and print-on-demand fabrics designed from her nature photography. Current works focus on the places where beauty, nature, science and spirit intersect. Transparent fabrics reveal the hidden. Geometry symbolizes the science behind nature.

Deborah Franzini (United States)

Deborah taught herself to quilt in the early 1990s during her recovery from a long illness. She continues to find joy in expression through quilting. Deborah combines the intimate nature of cloth and the meditative process of quilting by hand to create art that can be both beautiful and functional. Her work honors the roots of quiltmaking while making quilts that are fresh and uniquely her own. Deborah's work has been exhibited in Quilt Visions, the San Jose

Museum of Quilts and Textiles, and at the La Conner Quilt & Textile Museum in Washington. She lives in Mount Shasta, California with her husband, Bruce, and their dog, Wally.

Ali George (Australia)

Ali lives in the Scenic Rim, Queensland, Australia. She started traditional patchwork and quilting in 1987 and attended a Ruth Stoneley retreat exploring abstract ideas that became art quilts in 1991. Ali immersed herself in the warp and weft of a creative life. Her studio is a converted barn on a five-acre property adjacent to World Heritage listed Main Range National Park. It is a sacred space where stories and ideas are explored through stitch, thread, mark-making and cloth. Ali employs multiple techniques to represent familiar experiences of life, love and loss.

Valerie Hearder (Canada)

Val is a quilter, artist, teacher and author. She has taught in numerous countries and is the recipient of the Dorothy McMurdie Award for significant contribution to Canadian quilting conferred by the Canadian Quilters' Association. Val's work has been published in numerous publications including two books on small appliqué landscape, and she has exhibited internationally. For seven years she ran a fair-trade business importing textiles from women's collectives in South Africa and supported Grandmothers in Africa. Val now leads annual cultural and textile tours to her native South Africa. She currently lives with her family in Mahone Bay, Nova Scotia.

Gwen Hendrix (United States)

The discovery of new visual processes—one experience leading to the next—fuels Gwen's creative passion. She loves to draw and color. Learning to oil paint by watching Bob Ross on PBS led to formal classroom instruction in watercolors, mixed-media collage and acrylics. Exploring the cloth structure in its simplest form expanded Gwen's skills in spinning, weaving and crochet. A lengthy "paint dramatic surfaces for quilt tops" workshop forced her to reconsider a vow to never learn to sew. Gwen now embraces the world of sewing, quilting, dyeing and making fabric.

Gay Kemmis (United States)

Gay is a life insurance underwriter who also creates boldly colored, abstract textile-based artwork. She lives, works and creates in southern New Hampshire.

Catherine Kirsch (United States)

Catherine is a mixed-media textile artist from Worcester, Massachusetts, who completed the Art Cloth Mastery Program in 2011. She exhibits in New England and in 2013 had a solo exhibition at the University of Massachusetts Medical School. In June 2014, Catherine founded a critique group for Worcester area artists. When not in her studio, she is a marriage therapist practicing in Northborough, Massachusetts.

Sandra Kunkle (United States)

Large baskets brimming with flowers from her mother's garden, a pink silk frock for dress-up, multicolors of sandstone grated onto sand pies and the long green view from a high perch in the cottonwood tree embellish the aesthetics of Sandy's childhood. Seeking beauty in color, pattern and design, she combines dye surface design techniques on cotton, rayon and silk. The resulting fabrics are stitched by machine and embellished by hand.

Irene Landau (Australia)

After a busy career in information technology and the business world over the last forty-five years, Irene is enjoying a return to early interests in color and textiles. A home in Southern Tasmania provides a relaxing environment and the support of like-minded artists. She adores the sensational qualities of silk but equally enjoys the elegant simplicity of Baltic-inspired linen or embroidery—perhaps influenced by her Estonian heritage.

Vivian Mahlab (United States)

Vivian was born in Baghdad, Iraq, and spent her childhood in Tehran before moving to Austin to attend the University of Texas, where she received her bachelor's and law degrees. While practicing law and raising children, she learned quilting from a book, cutting and piecing her first Amish-style quilt by hand. Vivian soon began improvising and attended

the Alegre Retreat, where she learned about art quilts. Her next leap into improvisation was a fabric dyeing class at Nancy Crow's Timber Frame Barn studio in Ohio. Vivian attends a yearly independent study at Art Cloth Studios and continues to practice law full time in Austin.

Betsy R. Miraglia (United States)

Betsy received a B.F.A. in graphic design with an emphasis on printmaking and drawing from Moore College of Art & Design in Philadelphia, Pennsylvania. She has studied with many well-known papermakers and printmakers, and has exhibited extensively in the United States, Italy and Japan. Betsy's collagraph-printed, handmade paper work is about color, interaction and space, and also about patience, time and getting in touch with her inner spirit. Most importantly, it is an ongoing process of discovering new ways to record memories through visual expression.

Jan Myers-Newbury (United States)

Jan is known for her pieced quilts using hand-dyeing with various shibori techniques. She has exhibited and taught nationally and internationally, been included in thirteen Quilt National exhibits and in 1993 won Best of Show. Jan's work is in numerous permanent collections including the museum of the American Quilter's Society and the American Craft Museum. In 1999, her quilt *Depth of Field: A Plane View* was selected as one of the 20th Century's 100 Best Quilts. Jan lives and works in Pittsburgh, Pennsylvania.

Carol O'Bagy (United States)

Born in Montana and with a Bachelor of Fine Arts degree from the University of Montana, Carol continues to live and work outside of Stevensville, Montana. She also holds a design certification from the City & Guilds Institute in the United Kingdom. Carol works primarily as a fiber artist but also enjoys working in mixed media, off-loom weaving and sculpture. Her pieces have been shown in venues in Montana, Kansas, Washington and Utah. Currently, Carol is a member of the Montana Bricolage Artists, Studio Art Quilt Association and Surface Design Association.

Laurie Paolini (United States)

Laurie lives in Brentwood, New Hampshire with her husband of twenty-nine years. She received a B.A. in commercial art from Notre Dame College but was lucky enough to be a stay-at-home mom for many years, working occasionally as a freelance graphic designer. Laurie's passion is making things from cloth that she has dyed and printed. Her processes include a variety of surface design techniques: dying, painting, printing, batik. Laurie's current focus is on making up-cycled clothing from thrift store finds, mixed with fabrics and T-shirts featuring her daughter Sam Paolini's artwork.

Joyce J. Ritter (United States)

Joyce says that if her DNA were to be analyzed, there would probably be threads wrapped around her genes. Her Lithuanian grandfather was a tailor and it was his daughters who taught her to sew as a child. The craft ultimately led Joyce to quilting in 1976. She has focused solely on art quilts for the last six years.

Chris Rodrigues (United Kingdom)

Chris is a mixed-media artist inspired by color, materials, relationships and many aspects of the natural world. Studying fine art at Chelsea College of Arts, she worked to create structures in wood and fabric. Chris currently lives in West London and finds inspiration from both the urban landscape and green spaces nearby. Paper is vital in the creative process for Chris, often forming a grid or framework to which images and found objects are attached. Recent projects have focused on chronicling family history and the countryside using painted and textured paper and images arranged as a grid. Chris hopes to develop these ideas by creating structures and assemblages that include text and found objects.

Beth Schnellenberger (United States)

Beth is a fiber artist based in Jasper, Indiana, whose work has appeared in numerous juried exhibitions. She is an active member of several fiber art organizations, working to promote understanding of and appreciation for the medium. Beth was employed as a high school teacher for twenty-eight years in the field of business education, the last ten as business department chair for the Southeast Dubois County

School Corporation—Forest Park High School. Since retiring in 2007, she has created art on a full-time basis.

Mary Ruth Smith (United States)

Mary Ruth was born and raised in Virginia. She teaches surface design, weaving and off-loom classes at Baylor University, Waco, Texas. Mary Ruth's first position, following two degrees in home economics, was teaching art at Pi Beta Phi Elementary School in Gatlinburg, Tennessee. This experience steered her to pursue art in both her personal and professional lives, and to secure advanced art degrees. Mary Ruth's work has been widely exhibited in the United States as well as internationally. Two pieces in the International Exhibitions of Miniature Textiles in Szombathely, Hungary were selected for inclusion in the Gallery of Szombathely textile collection.

Martha Tabis (United States)

A child of the 1950s, Martha always loved dressing up. When she was thirteen, her mother fashioned a party dress from a picture in *Seventeen* magazine, and Martha decided she wanted to learn to do that. She learned to sew and worked in apparel buying for ten years after getting a master's degree in textiles and clothing.

Making traditional quilts was satisfying for many years, but in time, art quilts attracted her to the variety of materials and processes they represented. Martha's art is a joyful expression of gratitude for the inspirations of the natural world.

Joanne Weis (United States)

Joanne is a textile artist from Louisville, Kentucky, whose work can be found in numerous private collections around the country. After retiring from a career as a social worker, she graduated from the University of Louisville, Fine Arts Department, with a master's degree focused on fiber. Much of Joanne's recent work portrays the link between the earth's environment and the spiritual. Starting with white fabric and cord, she develops the fabric surface through a variety of dyeing and printing techniques. The final layer is typically stitched, adding detail and texture. In this way Joanne uses her fiber art to record a story of respect for and celebration of the world we've been given.

Carol Wiebe (United States)

Carol's hands and mind always itch to be active. Born to parents with hyperactive work ethics, her propensities toward reading and making art were considered a frivolous waste of time. But art offers Carol a way to process life as she lives it. Art has become so integral to her way of living and thinking she considers it a spiritual practice. That practice constantly supports and surprises her. Collage, mixed media, painting and the creation of handmade books are a few of her passions. Carol's work has been published in *Quilting Arts*, Workshop on the Web, *Fibre and Stitch* and in a number of other artists' published books.

"There are books you must read, and then there are books you must read, own and reread. *Creative Strength Training* falls in the latter category. The chapter topics reek of passion and emit loads of encouragement to give voice to your creative spirit. Jane is there to ensure you'll use it so as not to lose it!"

◆ **Marie-Therese Wisniowski**, director and founder of Art Quill Studio, NSW, Australia and former co-editor, *Textile Fibre Forum* art magazine

INDEX

Other fine North Light Books are available from your favorite bookstore, art supply store or online supplier. Visit our website at fwcommunity.com.

20 19 18 17 16 5 4 3 2 1

a content + ecommerce company

DISTRIBUTED IN CANADA BY FRASER DIRECT
100 Armstrong Avenue
Georgetown, ON, Canada L7G 5S4
Tel: (905) 877-4411

DISTRIBUTED IN THE U.K. AND EUROPE
BY F&W MEDIA INTERNATIONAL, LTD
Brunel House, Forde Close, Newton Abbot, TQ12 4PU, UK
Tel: (+44) 1626 323200, Fax: (+44) 1626 323319
Email: enquiries@fwmedia.com

DISTRIBUTED IN AUSTRALIA BY CAPRICORN LINK
P.O. Box 704, S. Windsor NSW, 2756 Australia
Tel: (02) 4560-1600; Fax: (02) 4577 5288
Email: books@capricornlink.com.au

ISBN 13: 978-1-4403-4495-4

Edited by Tonia Jenny
Designed by Breanna Loebach
Production coordinated by Jennifer Bass
Photography by Zenna James

DEDICATION

To the Rebel in each of you reading this book. Harness that energy and allow it to guide your Artist Self.

And of course, to Zenna.

ACKNOWLEDGMENTS

Many thanks to the Louisville, Kentucky independent study group, who witnessed the dawning of these ideas as a cohesive whole, and validated the use of the new terms we coined during that workshop year.

Thanks to Tonia Jenny and the F+W team for the guidance and support that made the book's birthing a joyful and informative process.

Thanks to Zenna James for patience and diligence not only where the photography was concerned, but also for attention to the minute details required to keep communication and organization engaged as we worked to collect releases, permissions, bios and artwork. You are the best.

Thanks to K Wayne Harms for providing illustrations that were exactly what I had in mind and for explanations related to the digital world that I may not have understood but that worked for me anyway!

To Joshua Duke for the many conversations we shared while these ideas were incubating, each of which served to ground one more of the ideas floating above my head.

Deep gratitude and thanks to the hundreds of students who participated in the first online AST classes. You helped me gain greater clarity and footing with the ideas in my head. And thanks especially to those who stepped forward graciously to share their writing and artwork.

METRIC CONVERSION CHART		
To convert	*to*	*multiply by*
Inches	Centimeters	2.54
Centimeters	Inches	0.4
Feet	Centimeters	30.5
Centimeters	Feet	0.03
Yards	Meters	0.9
Meters	Yards	1.1

ABOUT JANE

Jane Dunnewold is a mixed-media artist with a passion for surface design—patterning and printing processes—employed on textile surfaces. Her career launched at the Southwest School of Art, where, as chairperson of the Surface Design Studio, she managed a dozen other artist/instructors and wrote programming for classes and workshops in dyeing, printing, color and design.

In 1996, Fiber Studio Press published *Complex Cloth*, considered a groundbreaking approach to combining surface design processes as layers on a single length of fabric. The popular book was in print for almost twenty years and was joined by several other books authored by Jane including *Finding Your Own Visual Language* (co-authored with Leslie Morgan and Claire Benn), *Improvisational Screen Printing* and *Art Cloth: A Guide to Surface Design on Fabric*, published in 2010 by Interweave Press.

Jane's artwork is widely exhibited and has garnered numerous awards including the Quilt Japan Prize (2002) and the Gold Prize (2002) at the Taegu International Textile Design Competition (Korea), inclusion in Quilt National 2015, and one-person exhibitions at the Visions Art Museum (San Diego/2016) and Fibreworks (Alberta, Canada/2016). She is a former president of the Surface Design Association.

Jane evolving understanding of how creative process intersects with human psychology and spirituality is reflected in her current work, which explores these topics through evocative combinations of surface design with vintage and appropriated textiles. At heart a teacher and guide, she offers online classes on a variety of subjects and maintains Jane Dunnewold Studios in San Antonio, assisted by media manager and daughter, Zenna James; Pema, the wonder dog; and an ever-changing assortment of cats and students.